Botanical Butterflies

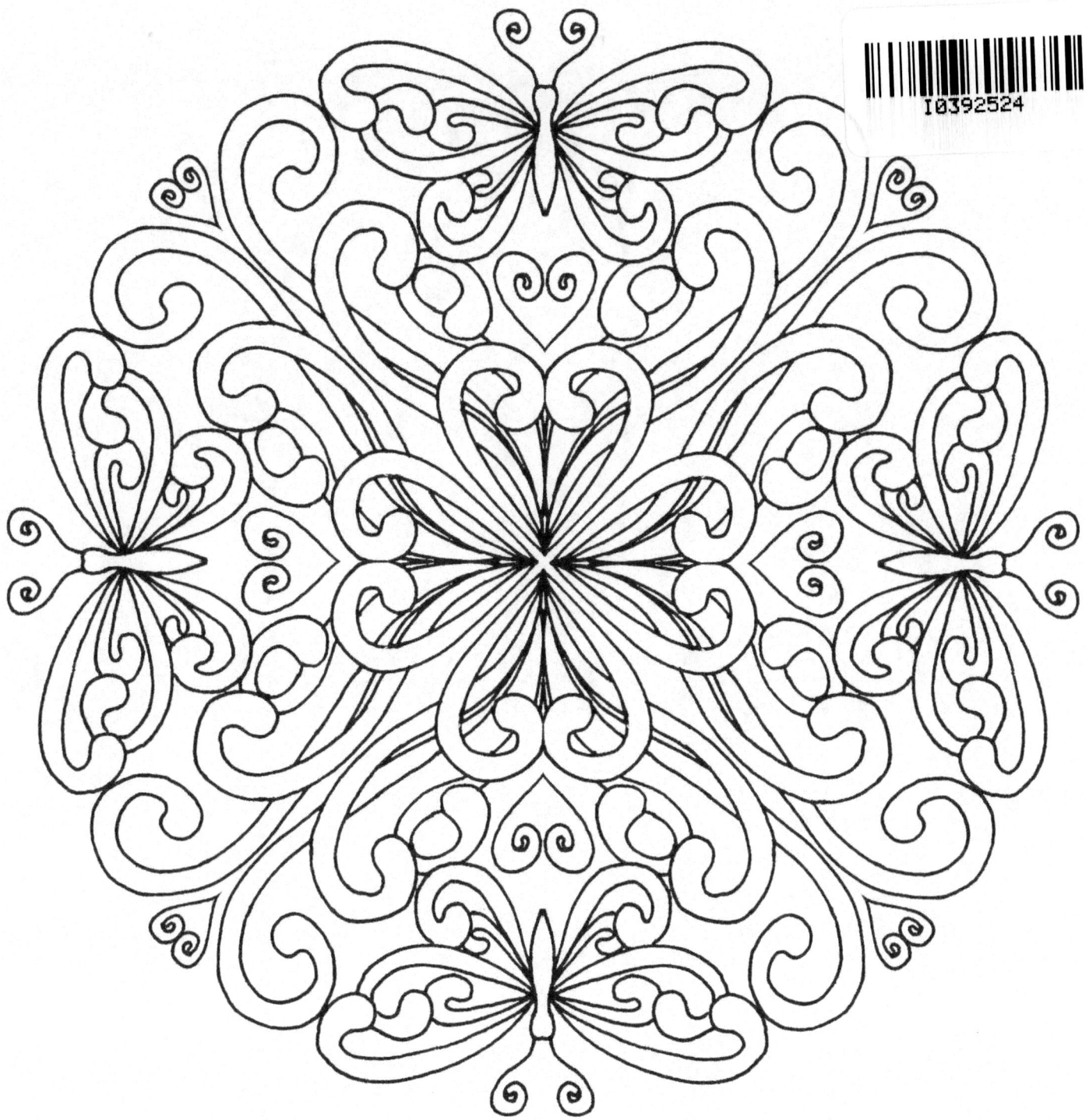

All images inside this book ©Tabitha Barnett/ Tabby's Tangled Art 2016 for personal ue only. Images may not be posted online in black and white form. I do, however, encourage you to post your colored pages online. I love to see your interpretation of the line art. Visit www.facebook.com/tabbystangledart and post your colored pictures there. Have fun and enjoy!

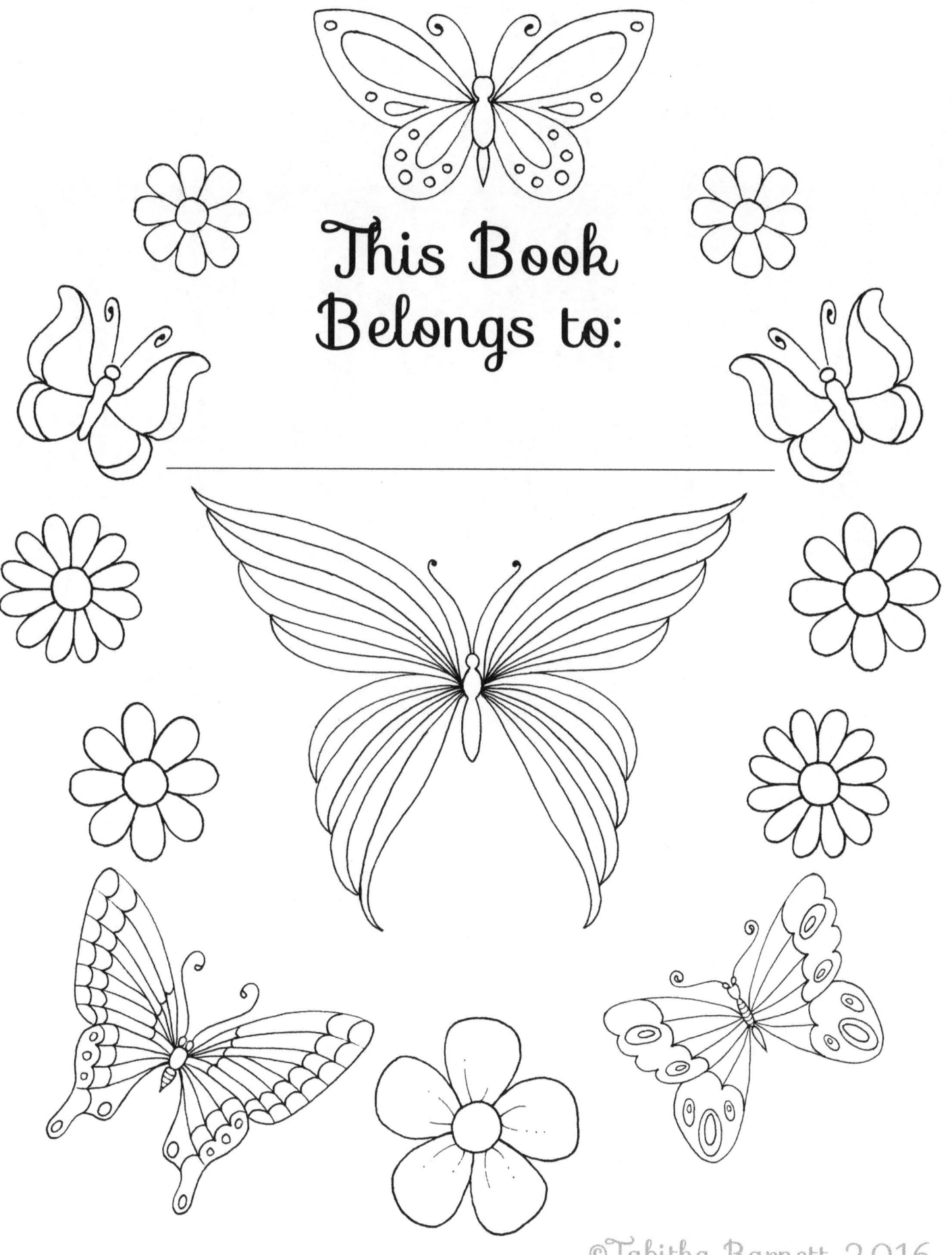

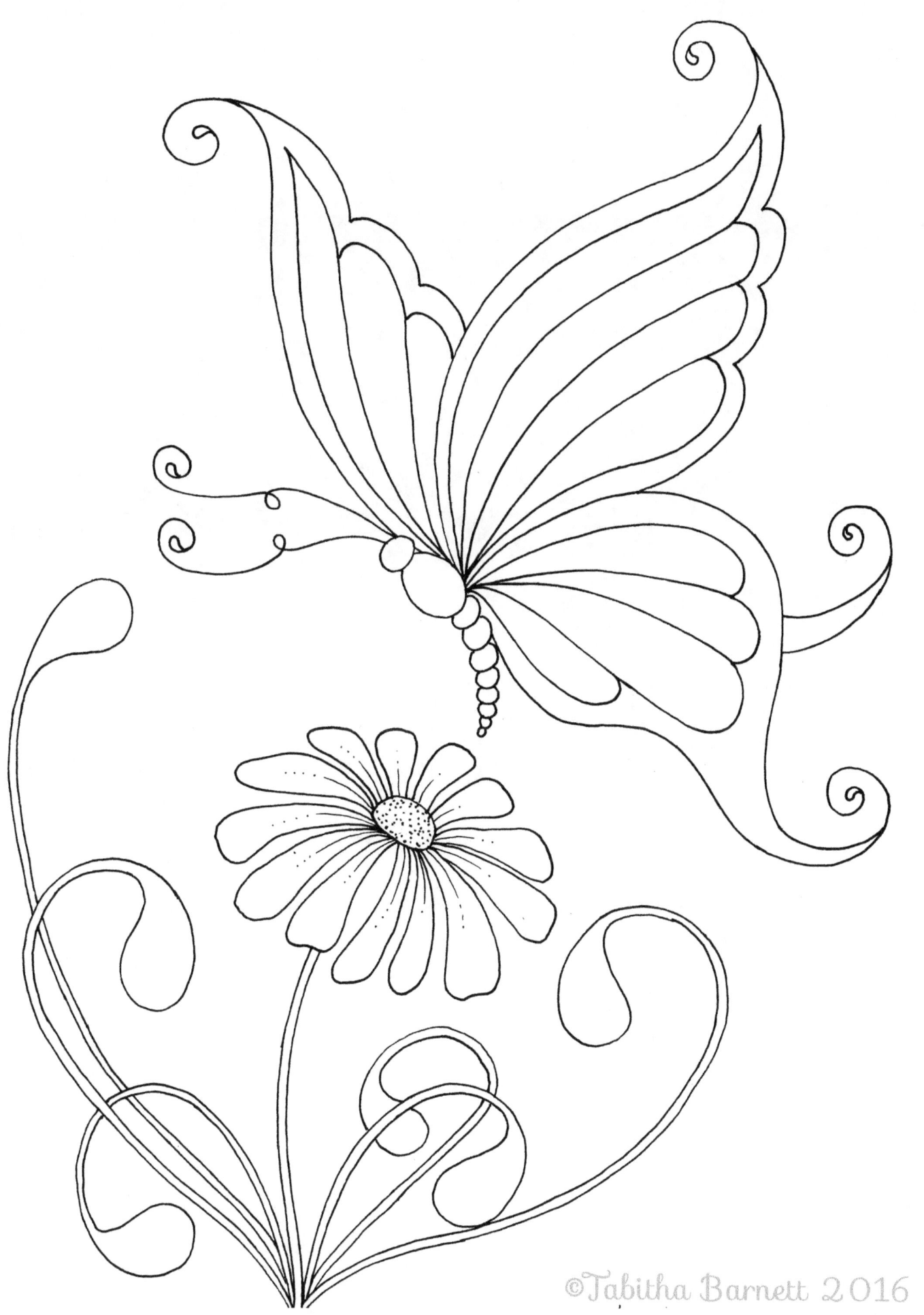

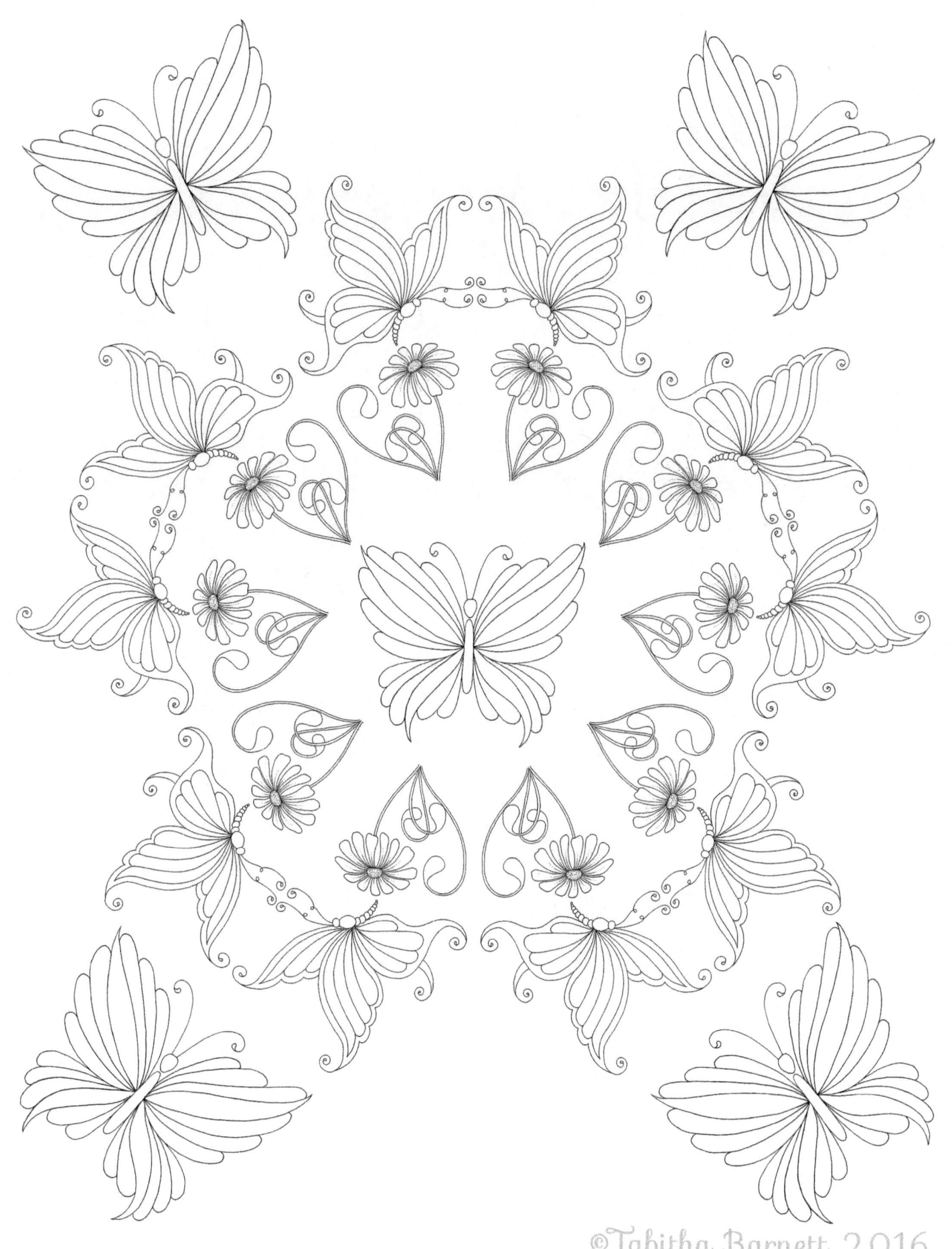

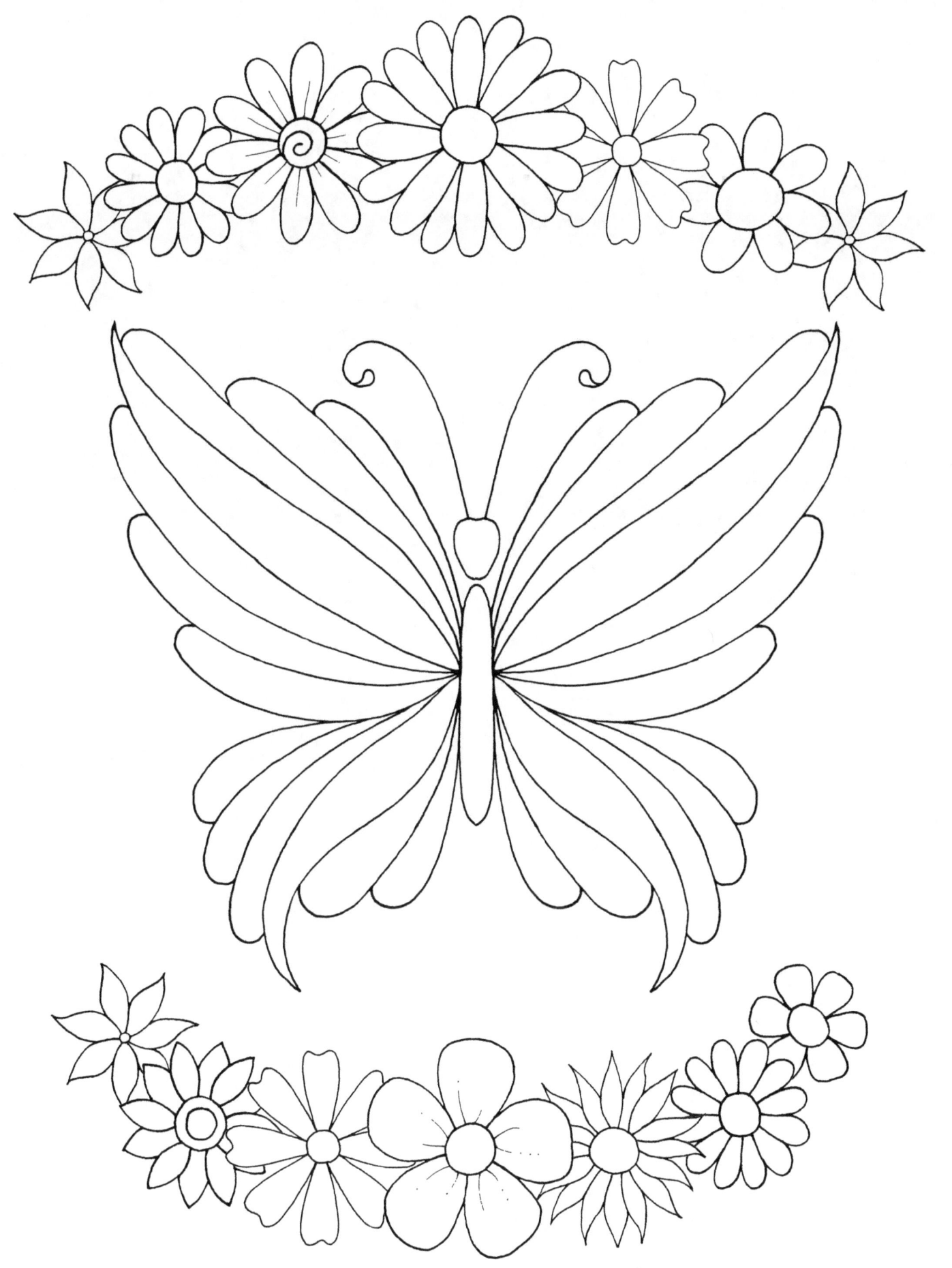

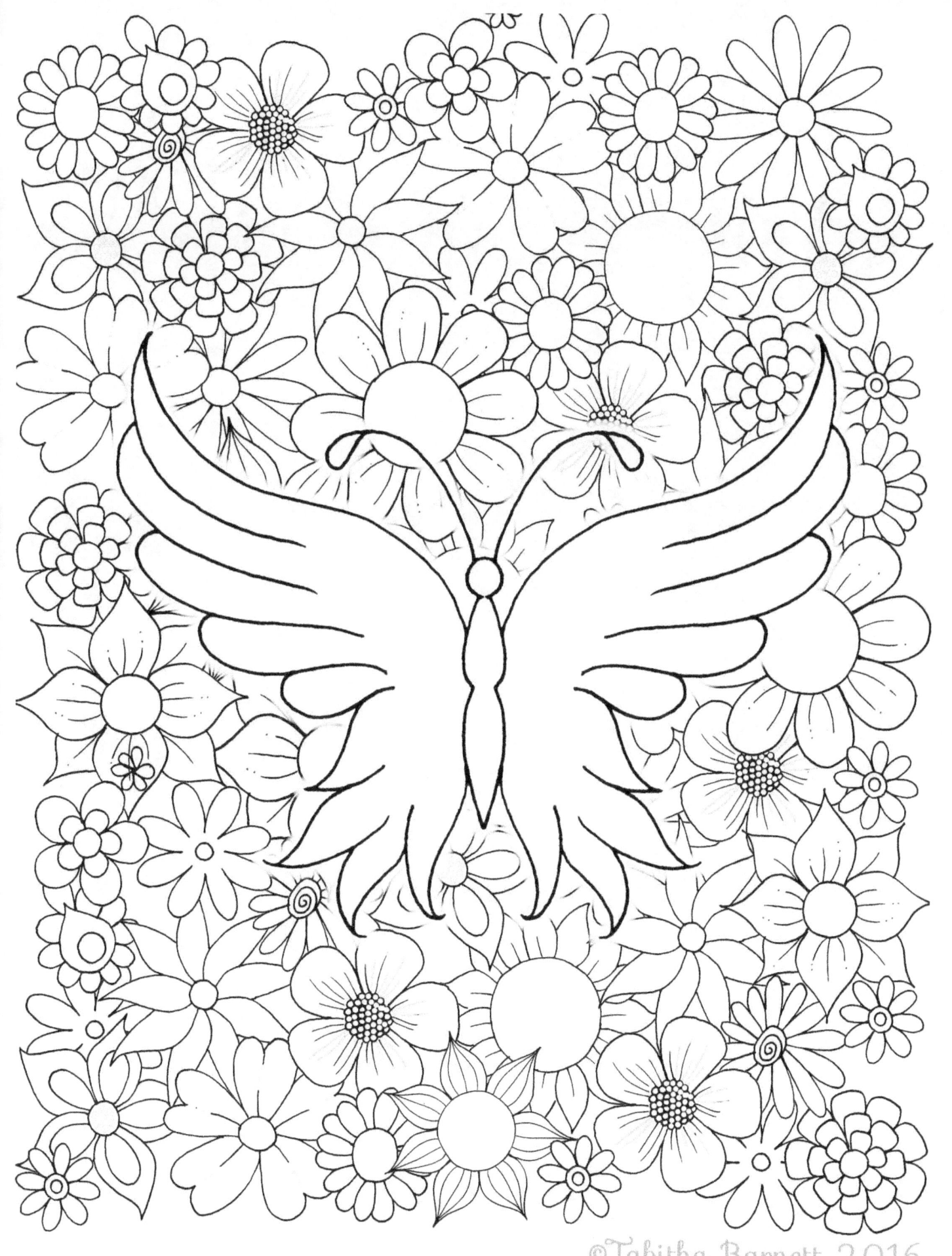

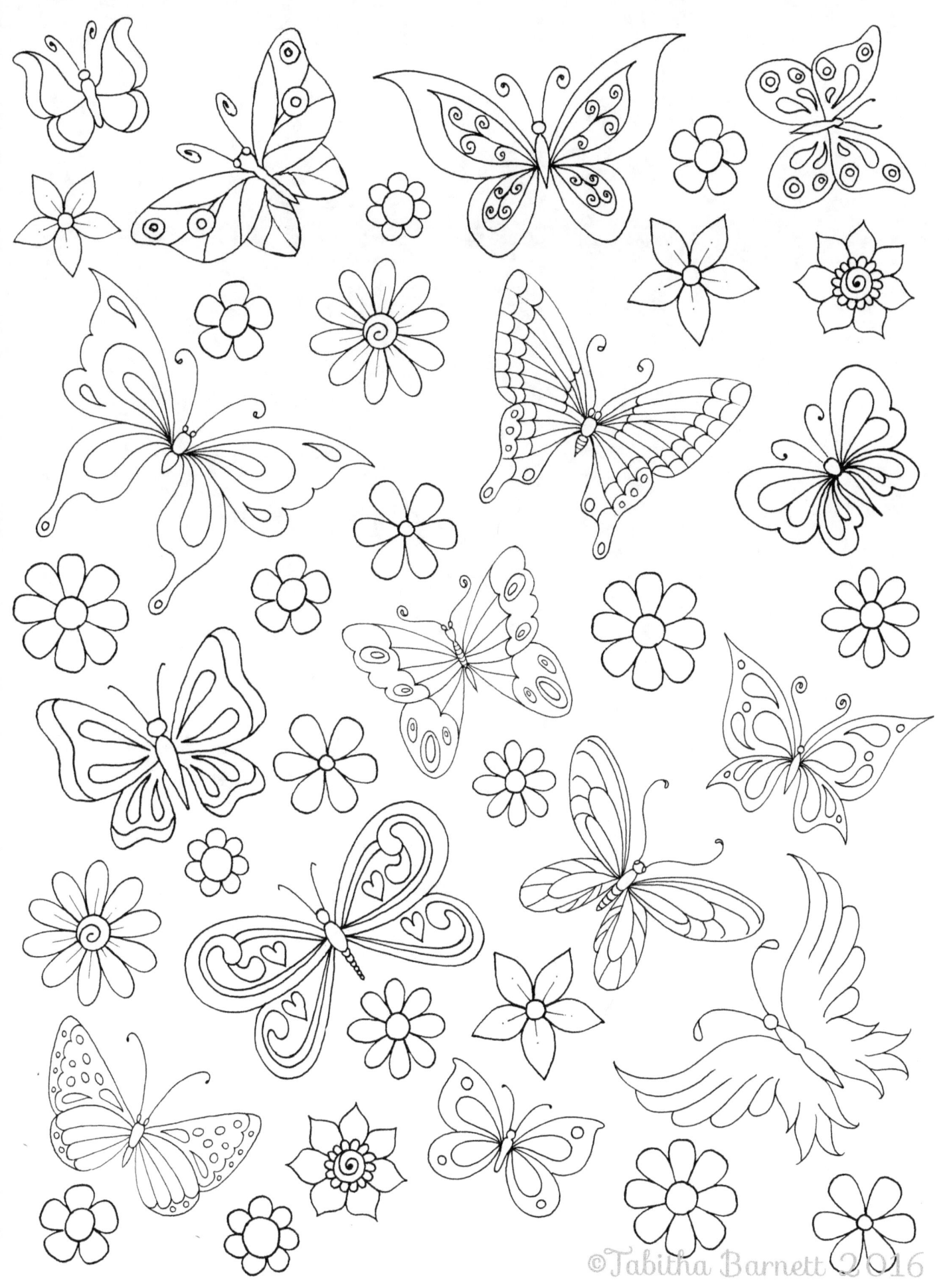

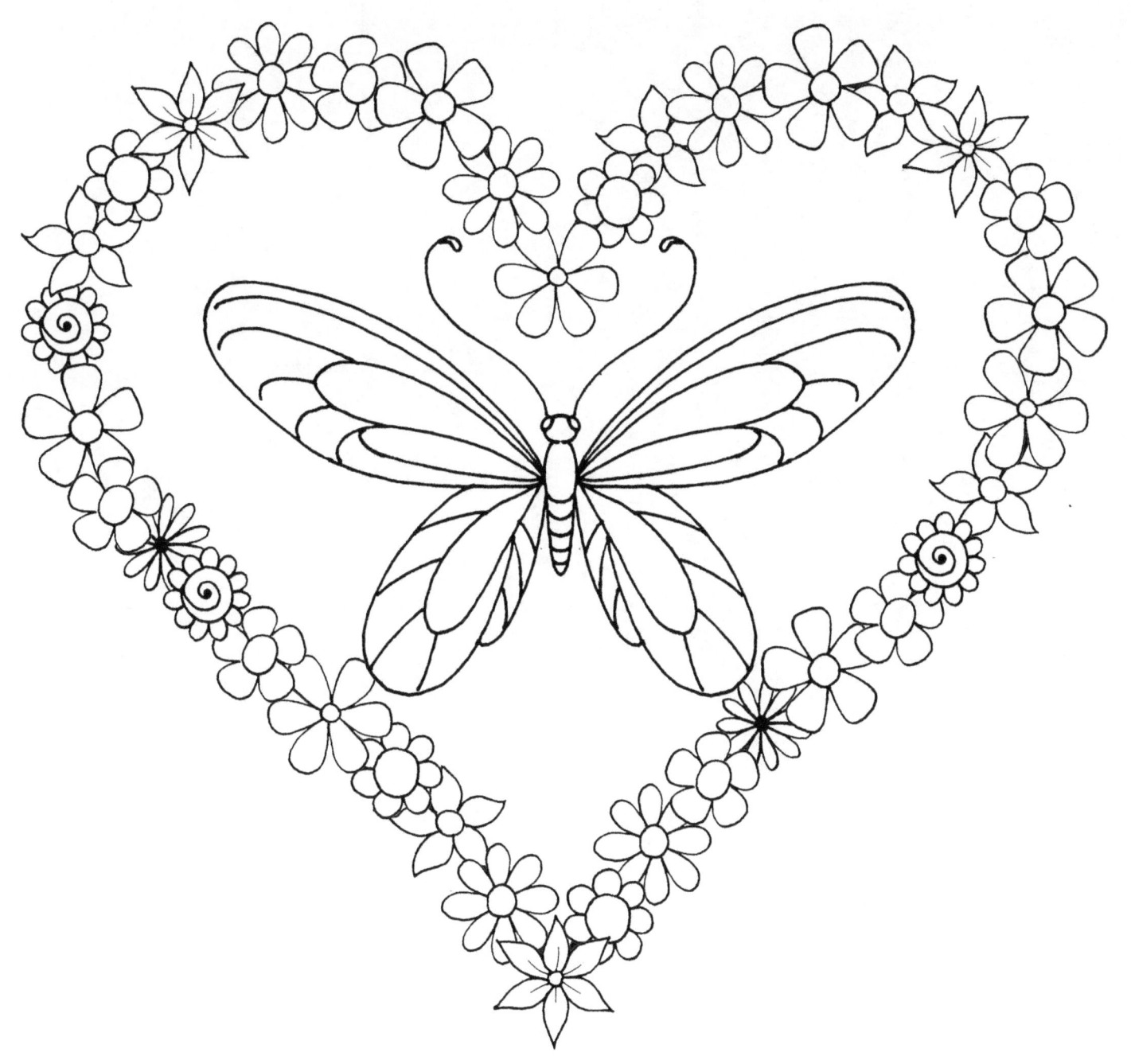

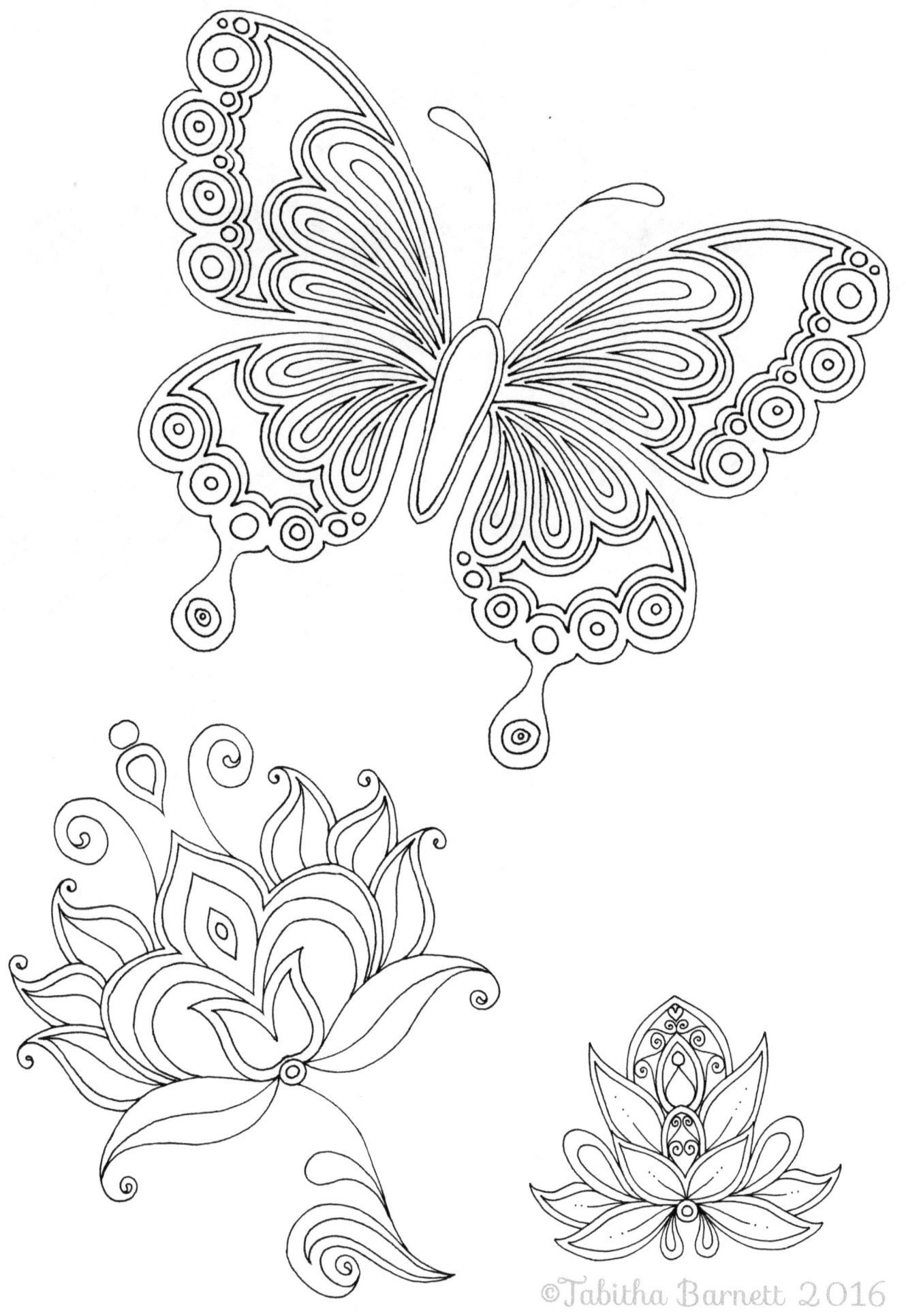

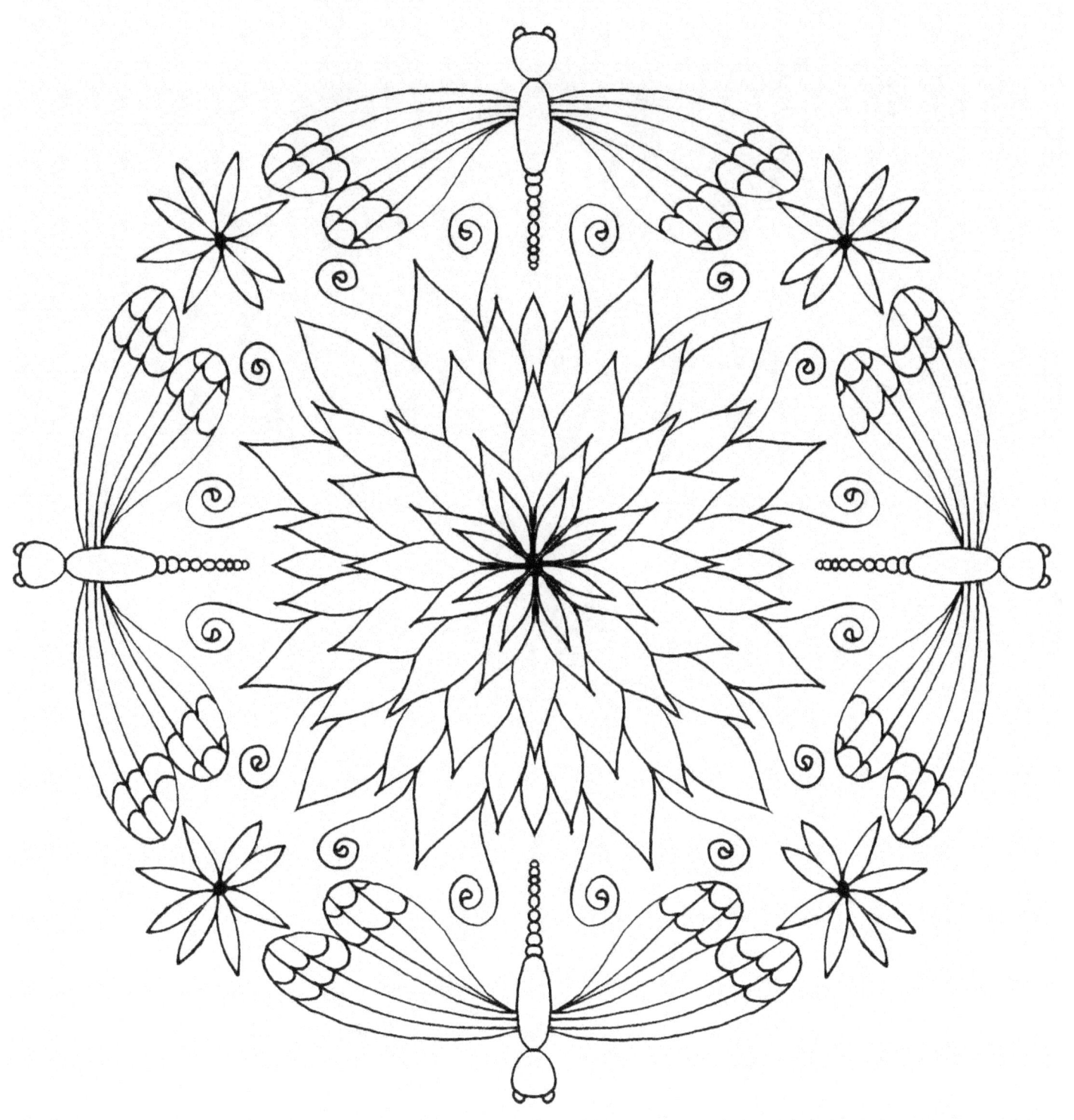

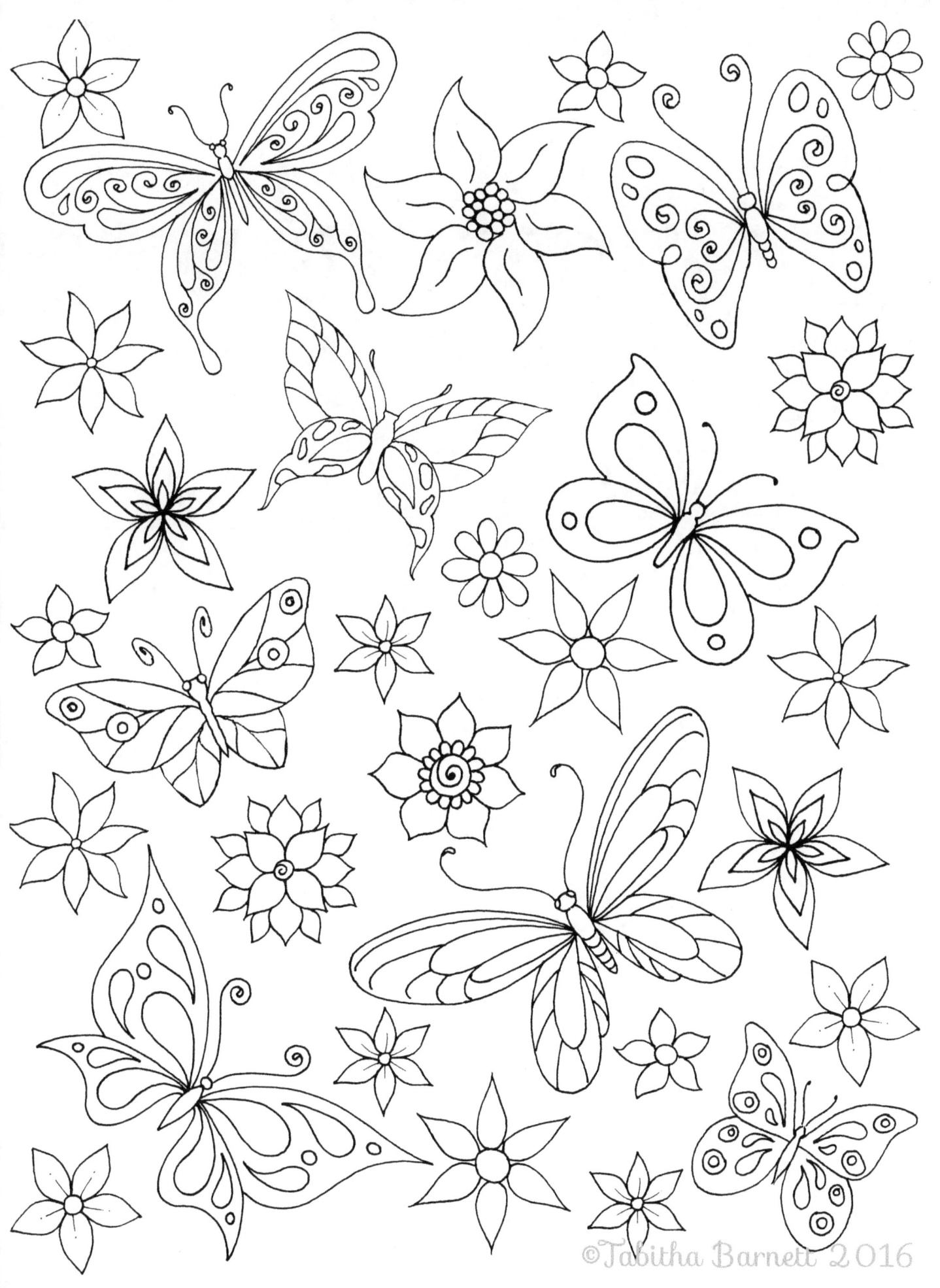

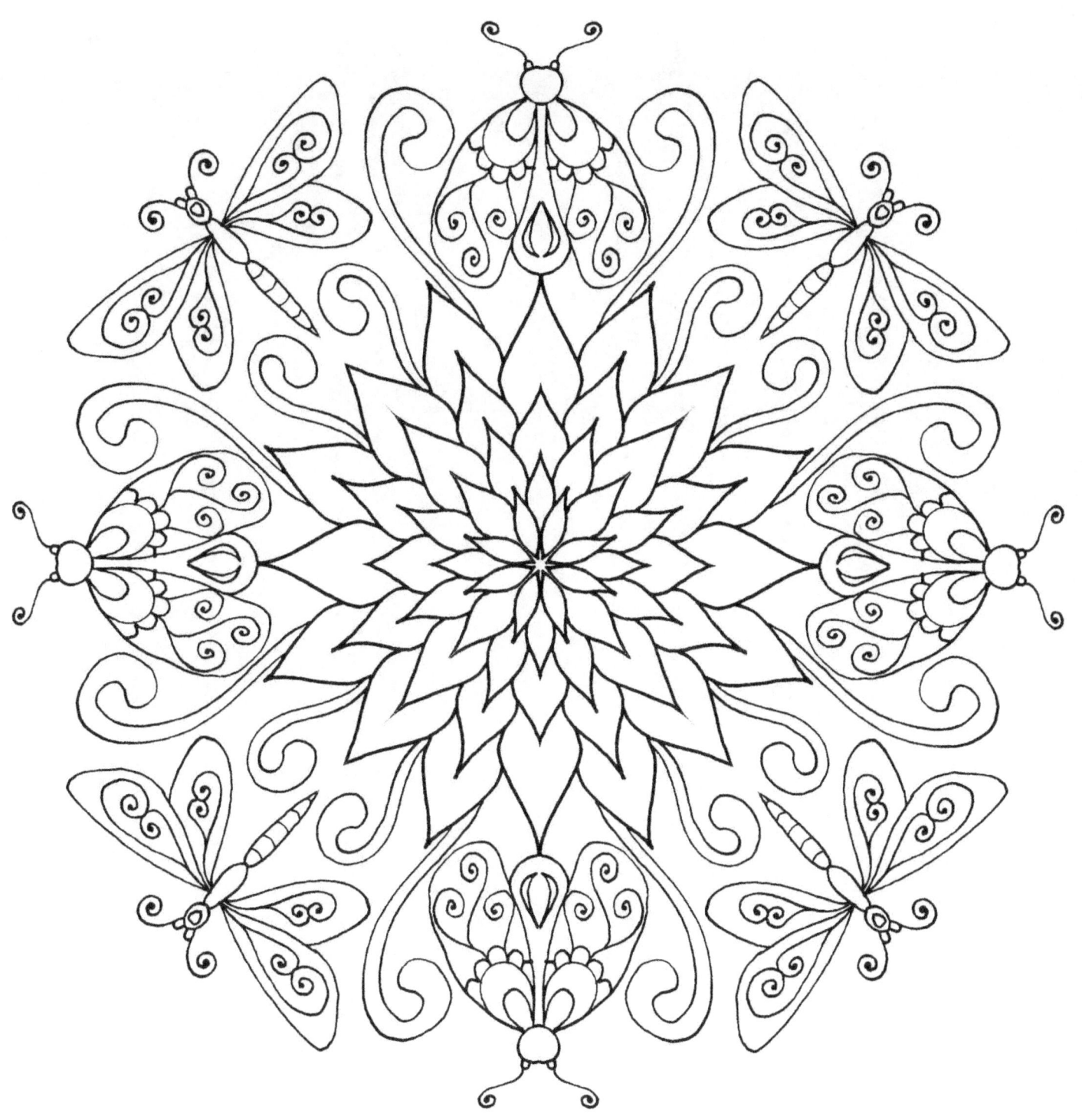

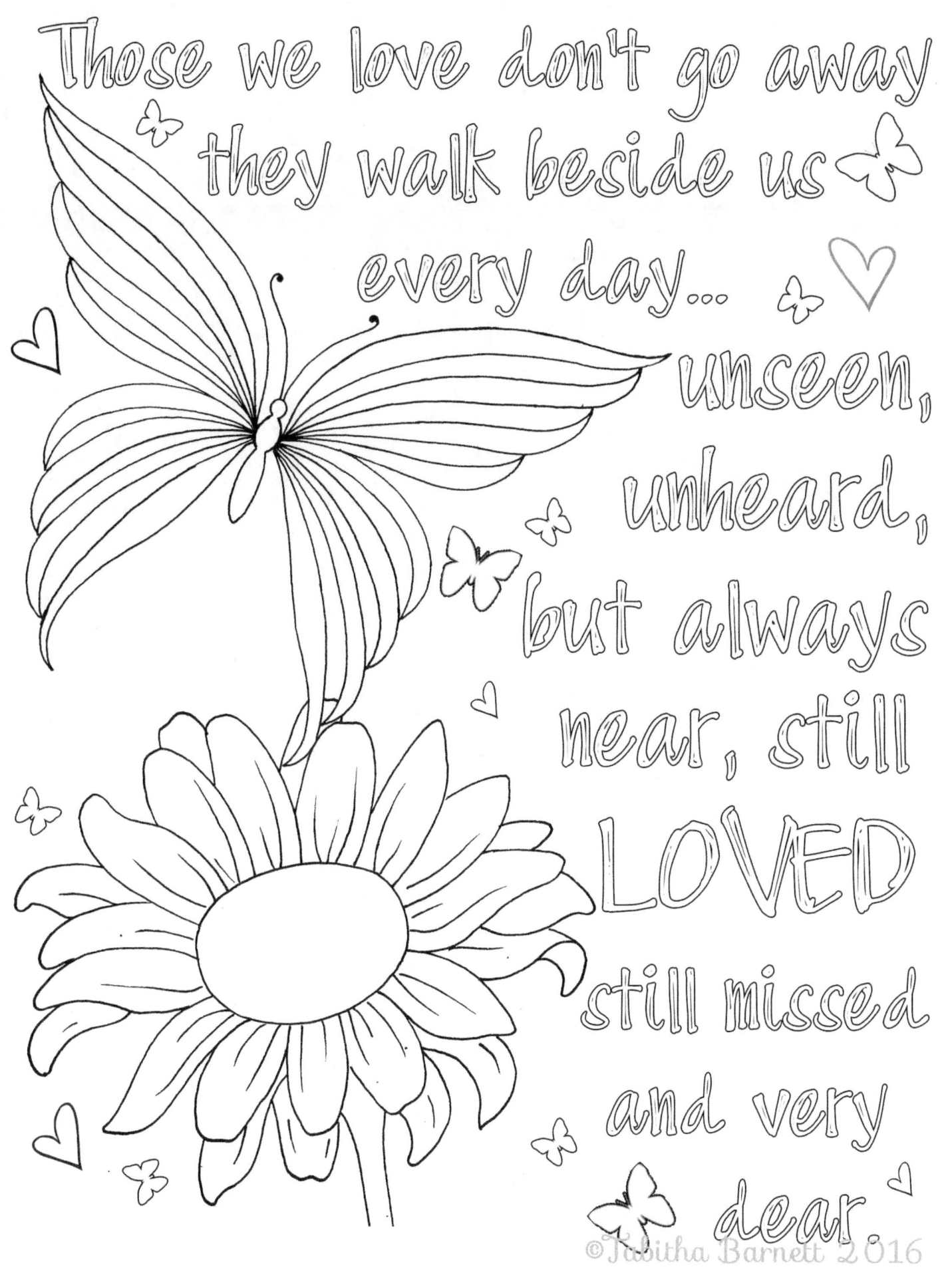

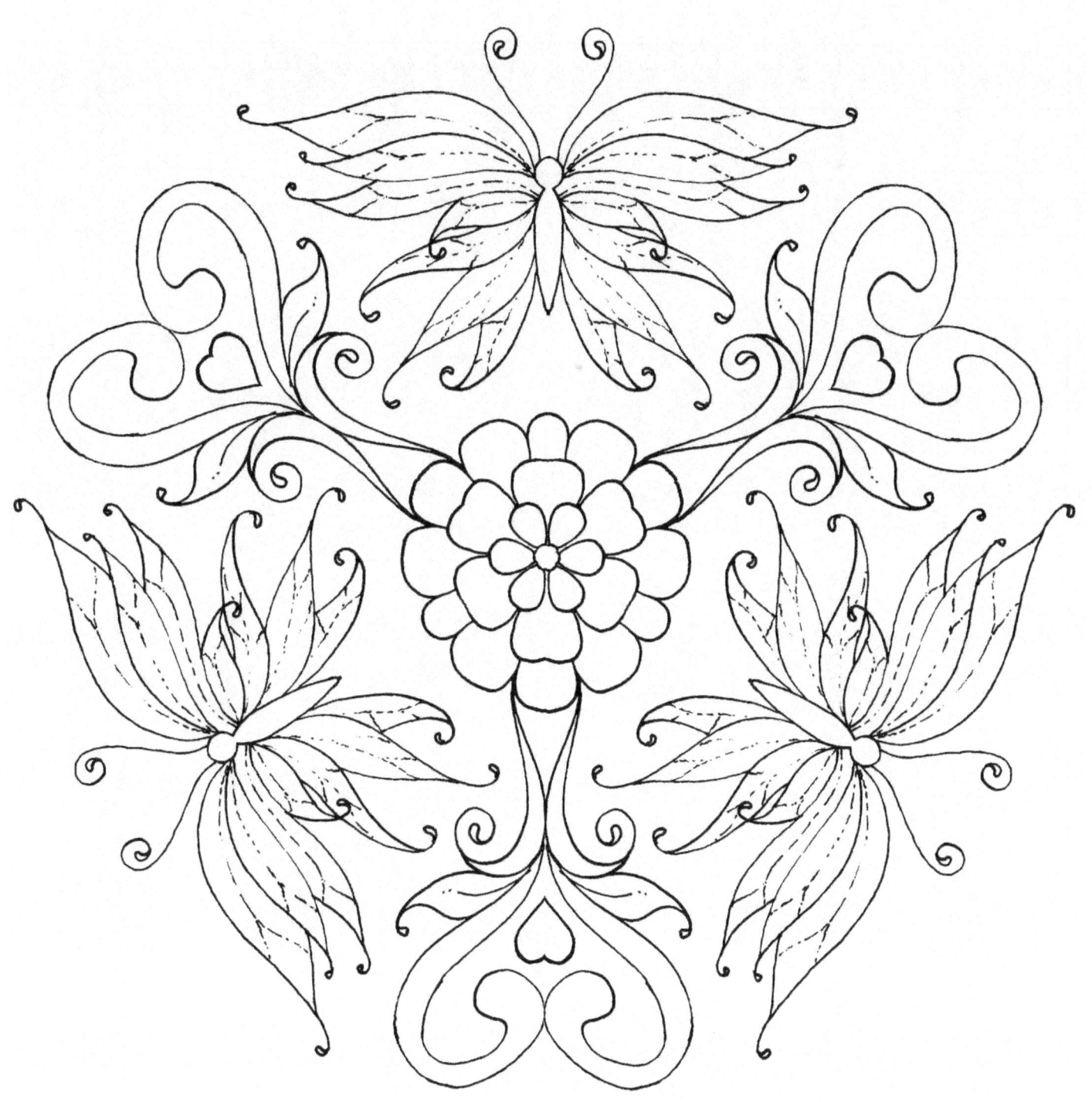

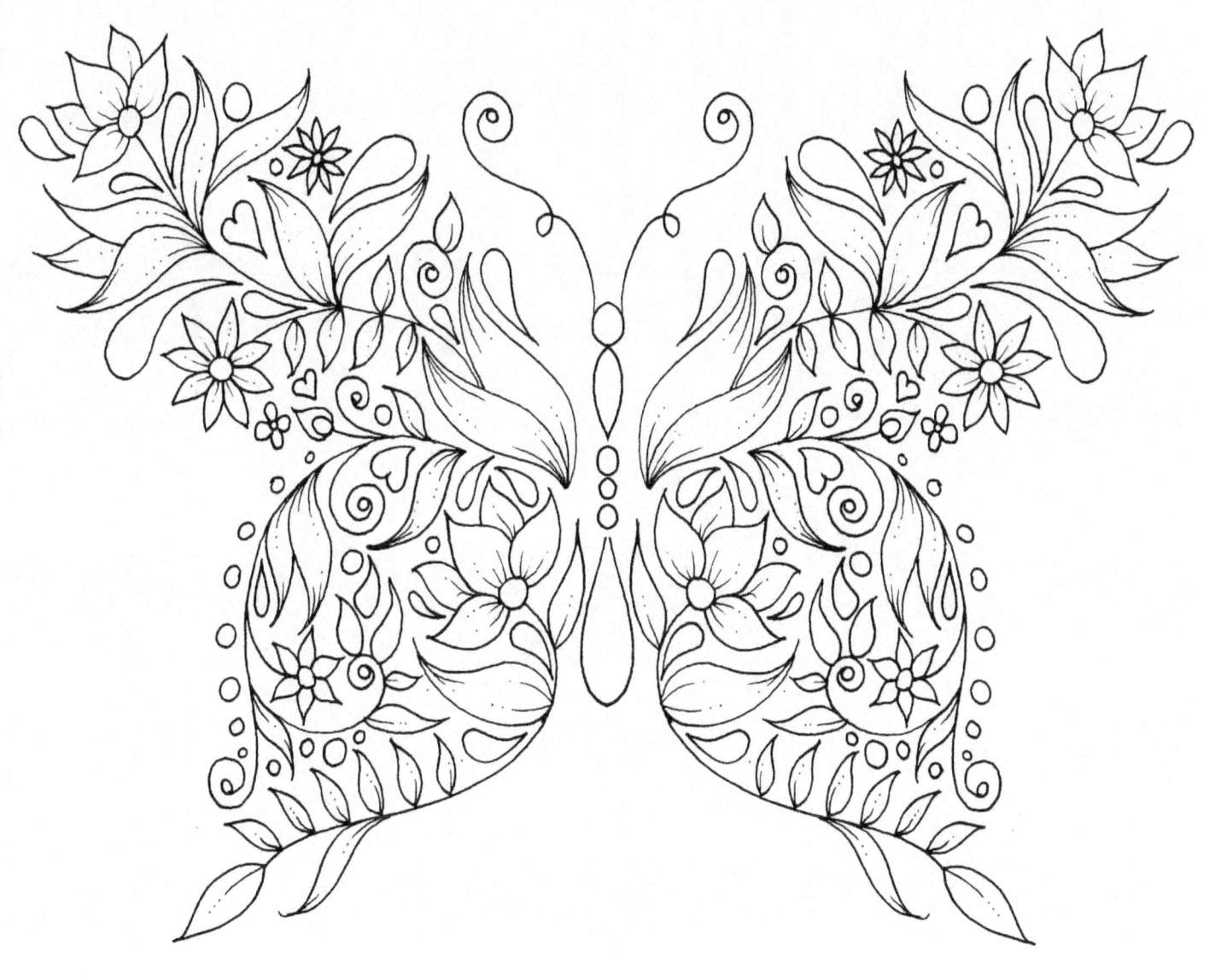

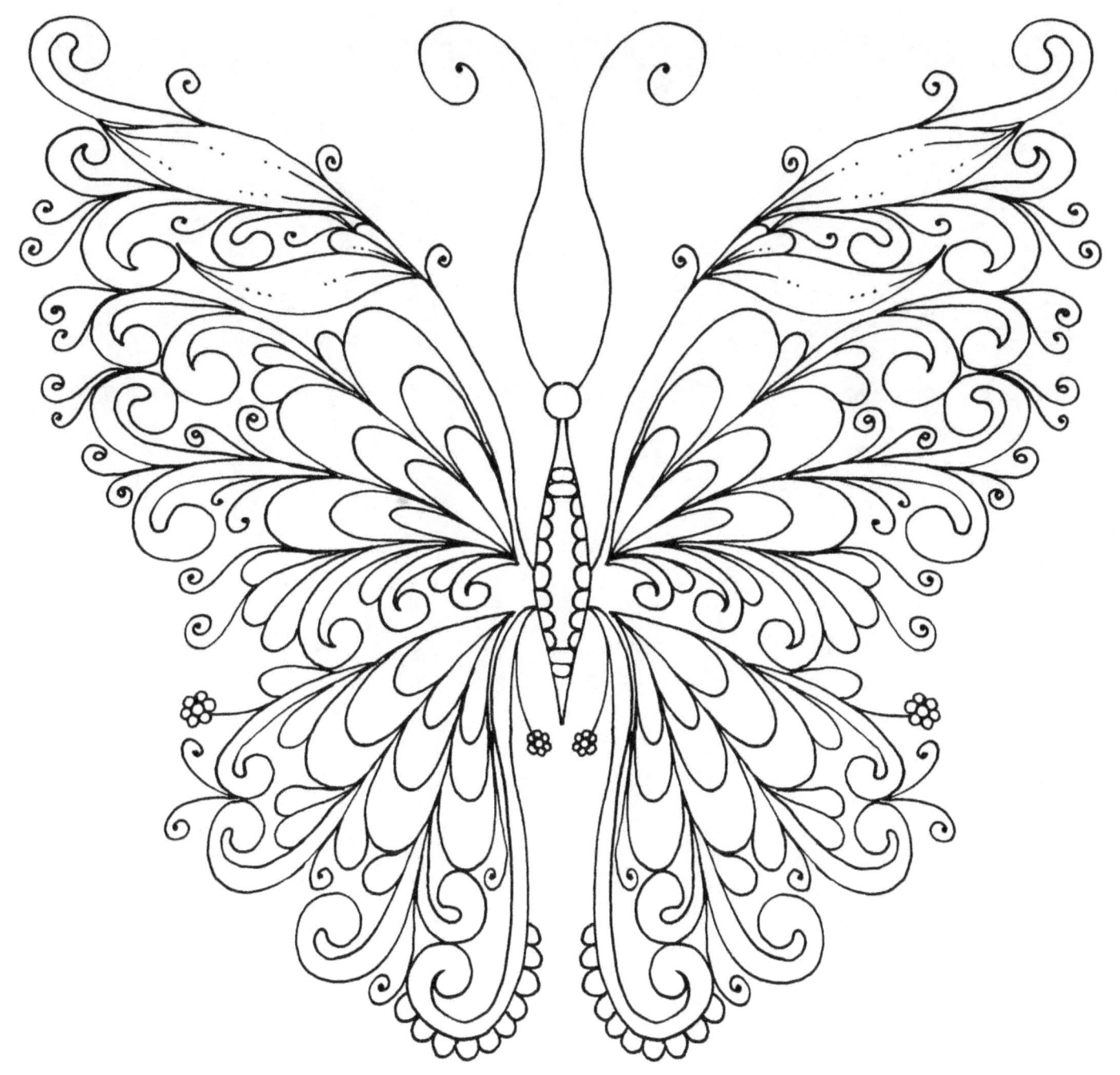

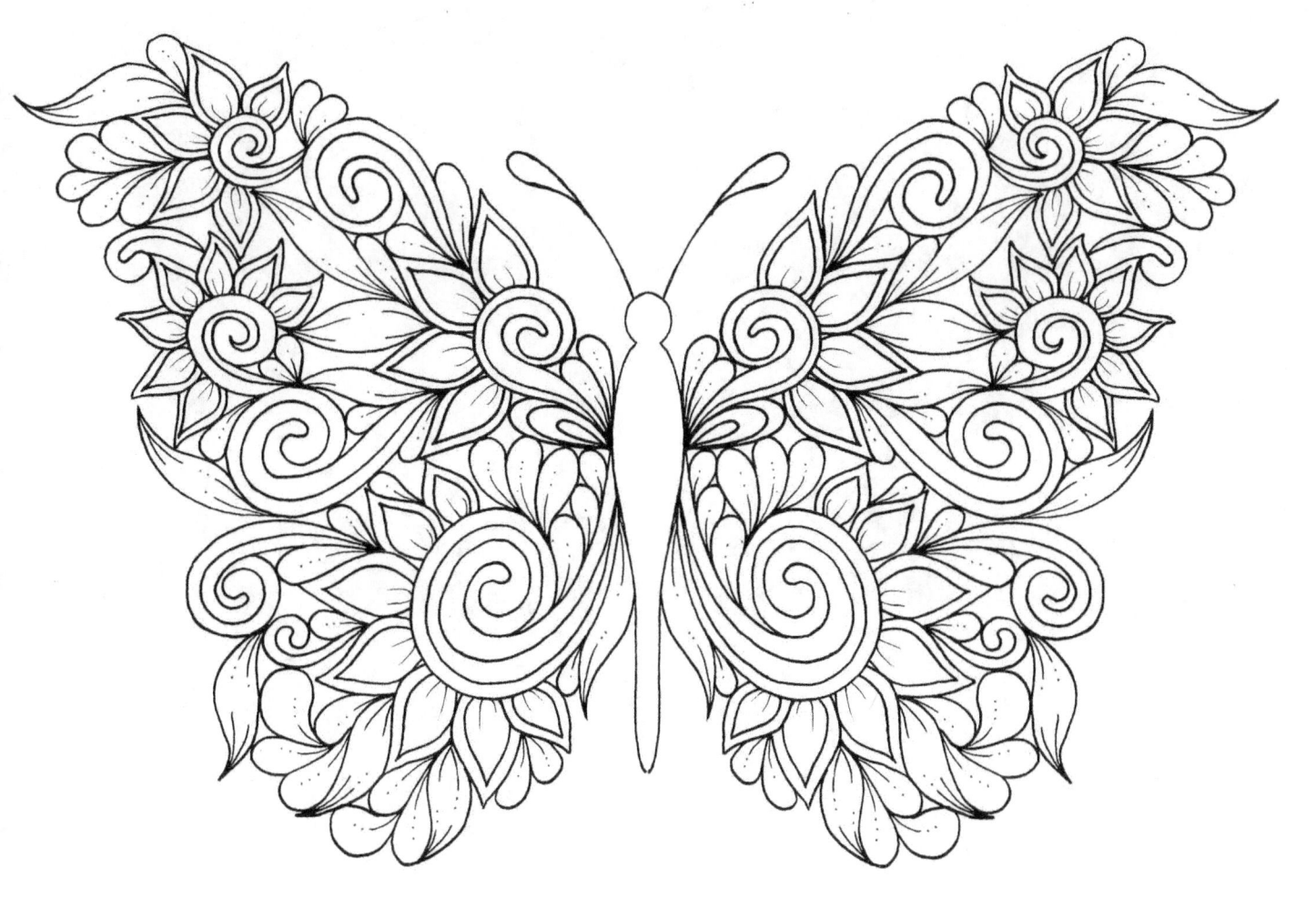

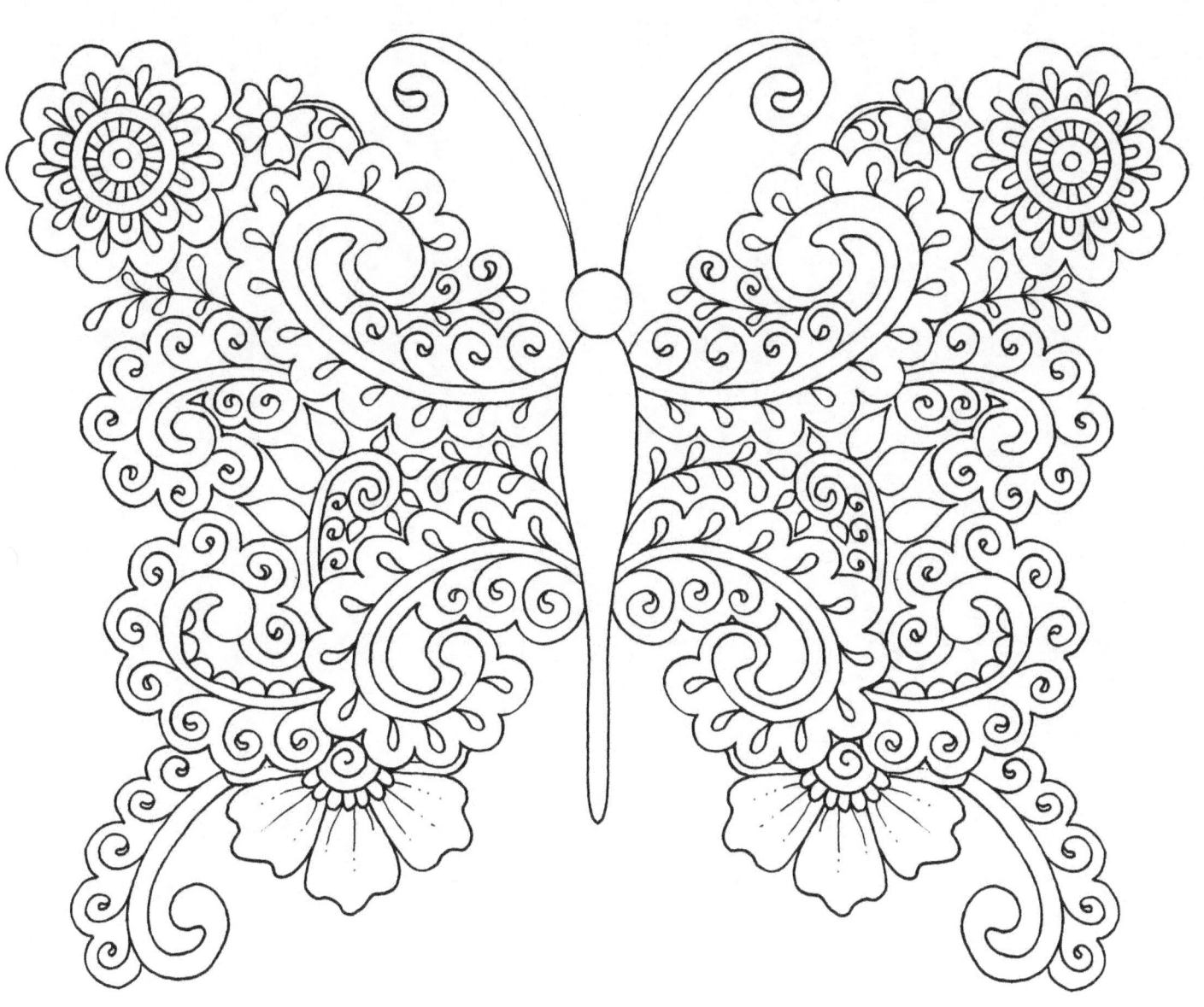

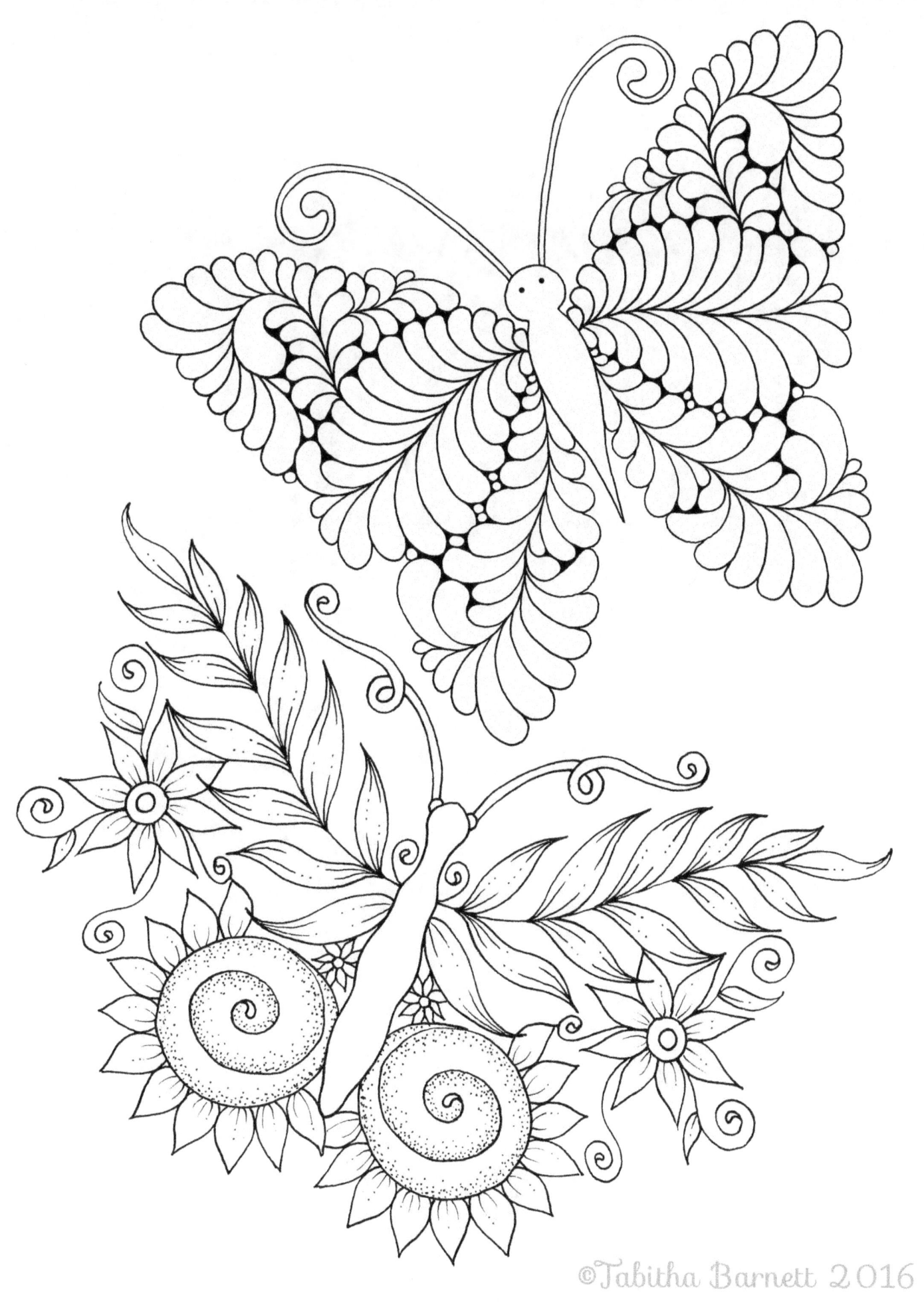

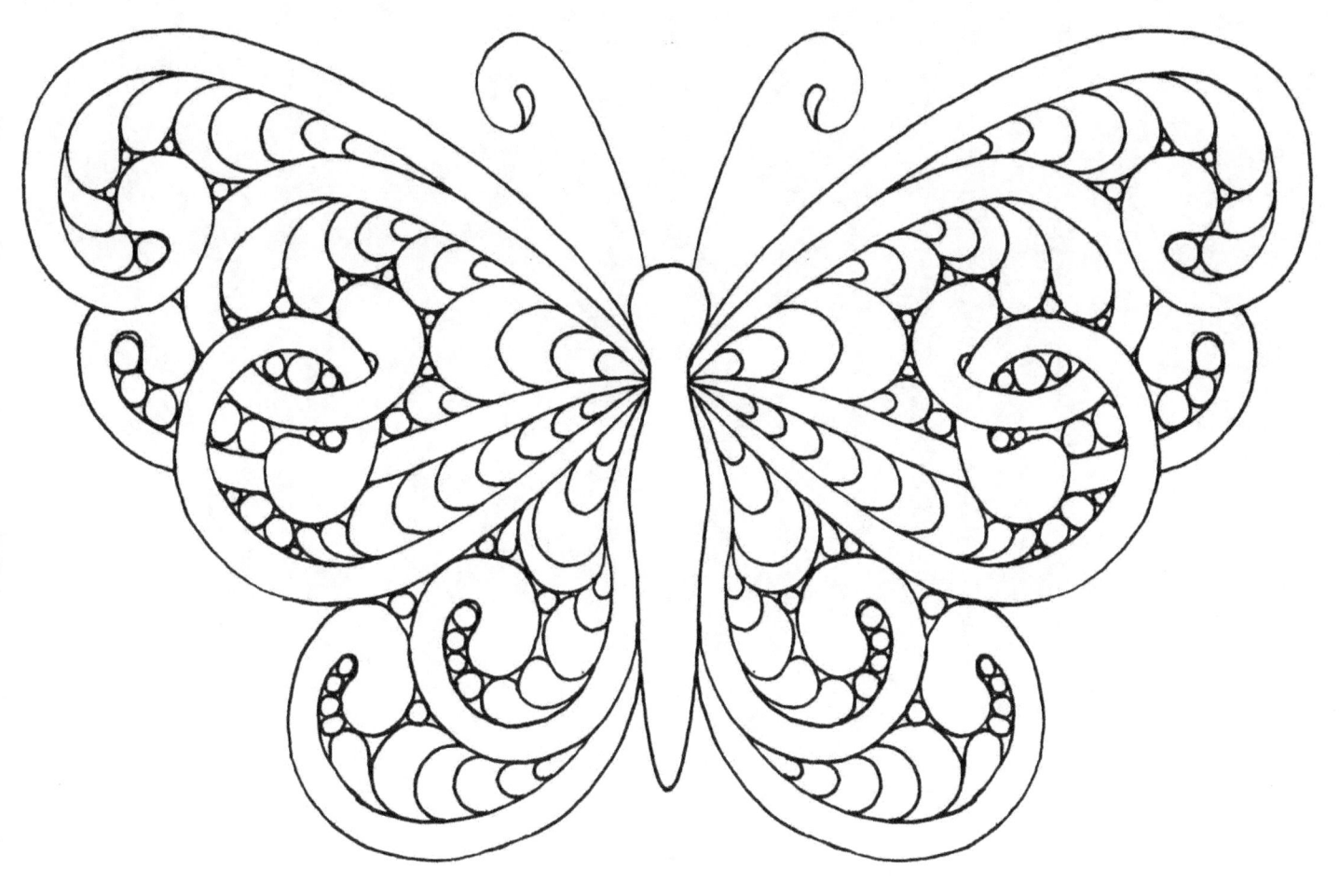

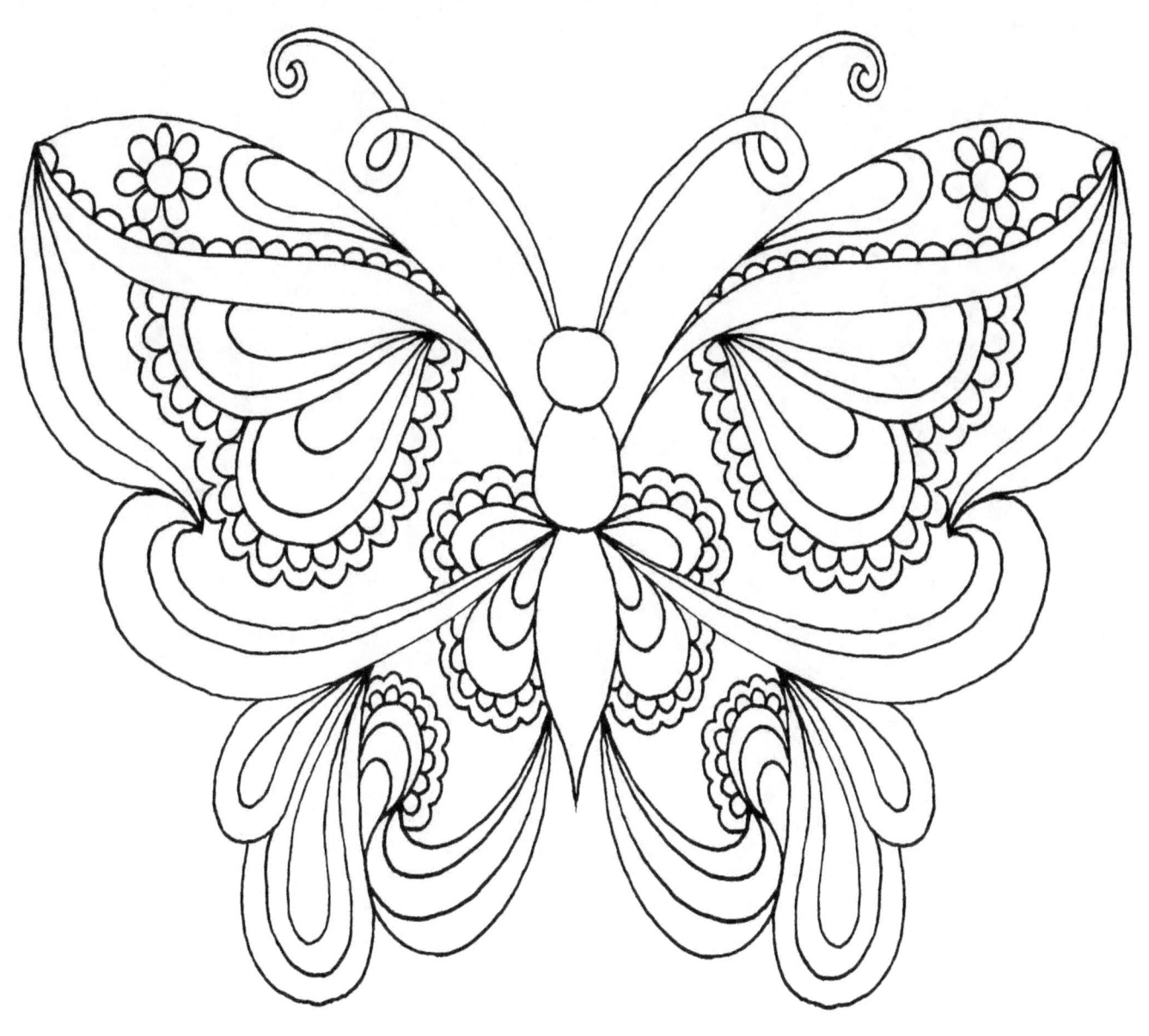

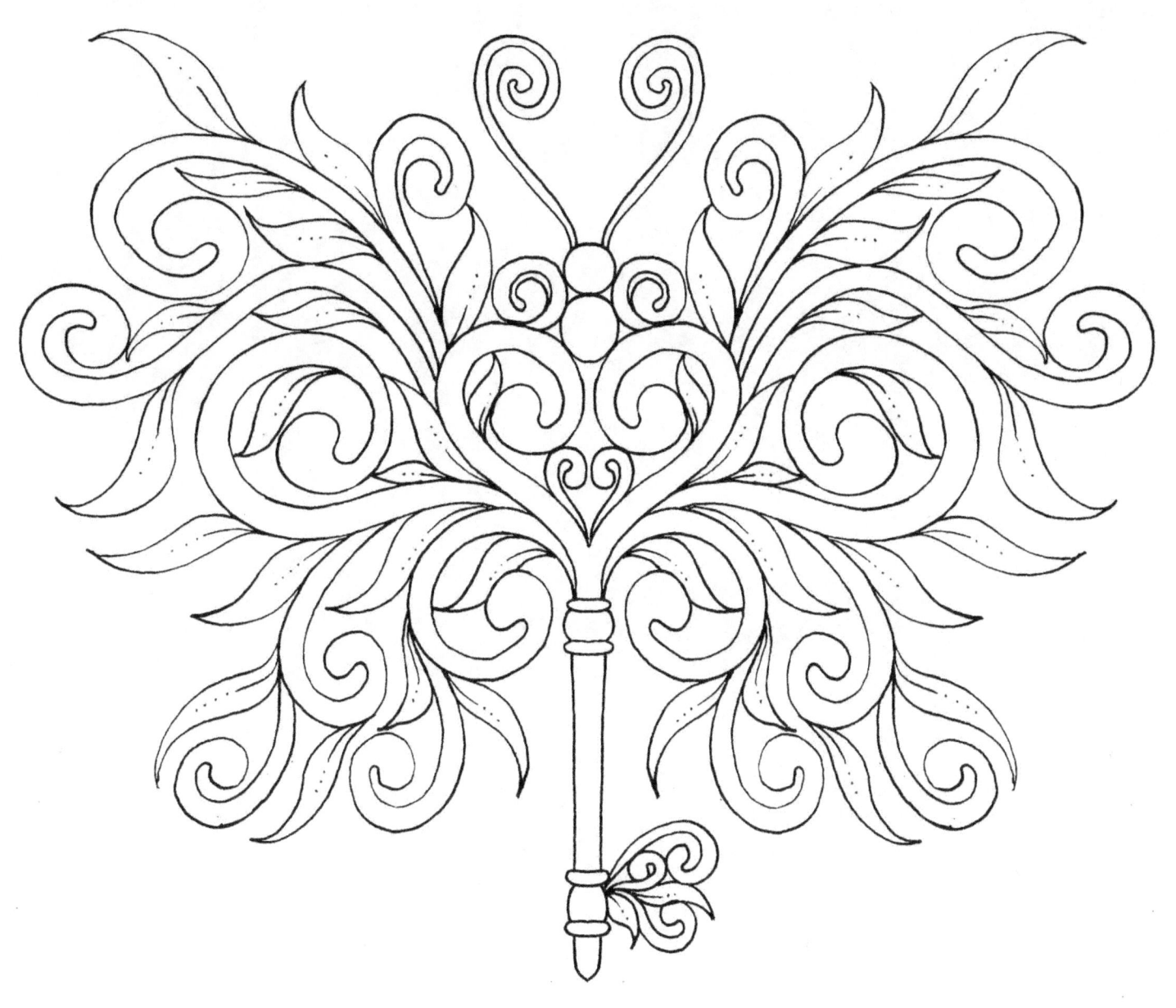

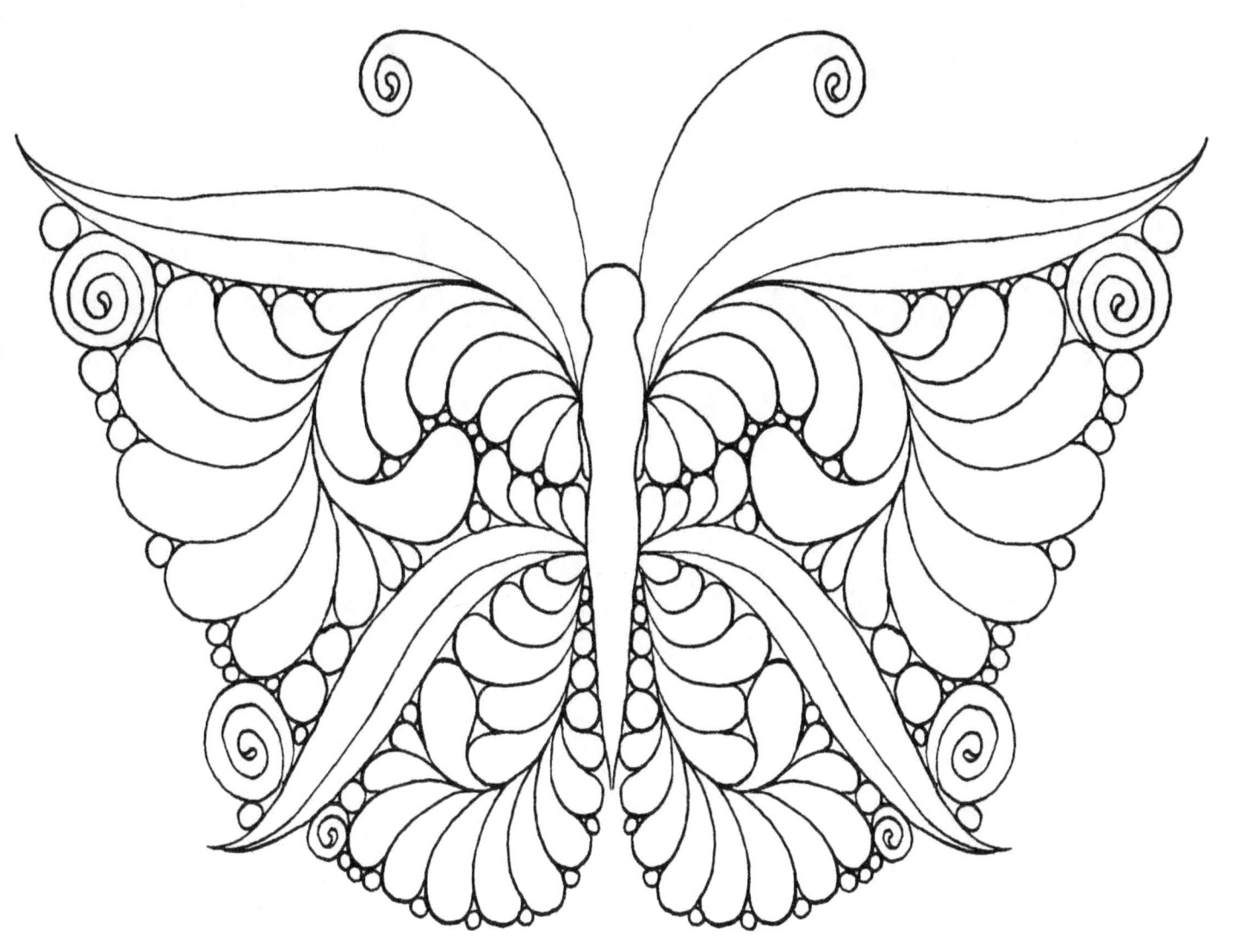

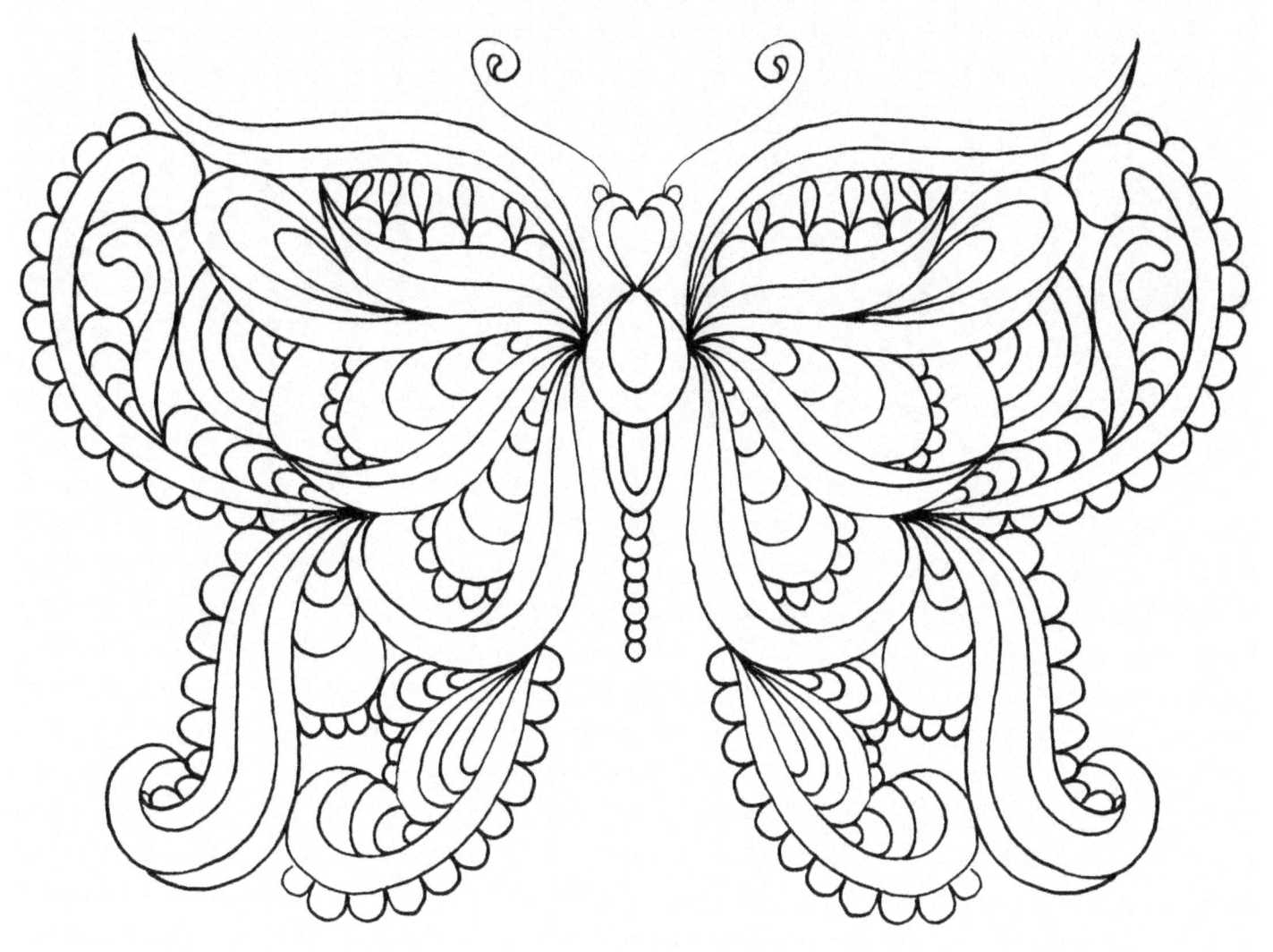

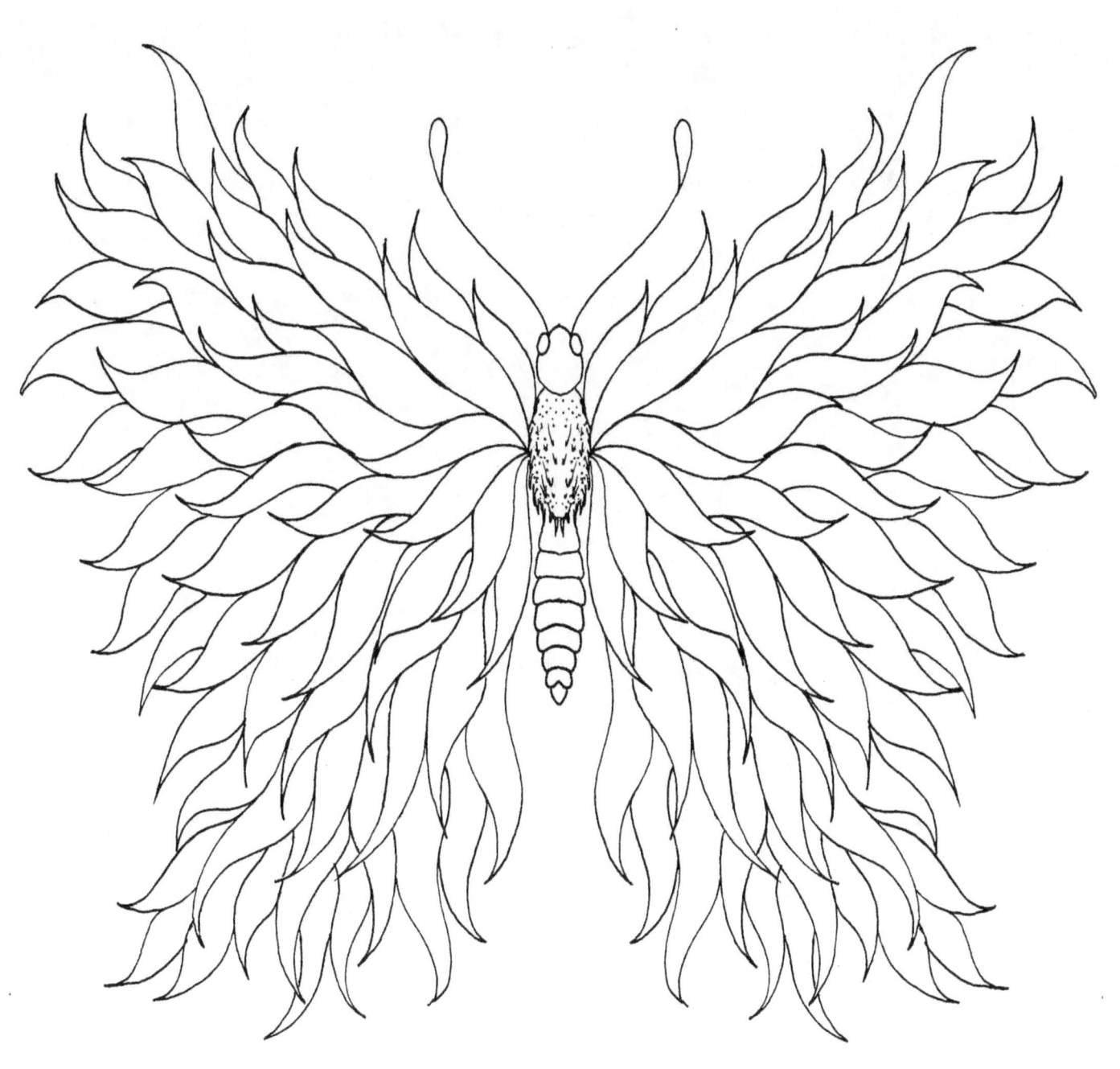

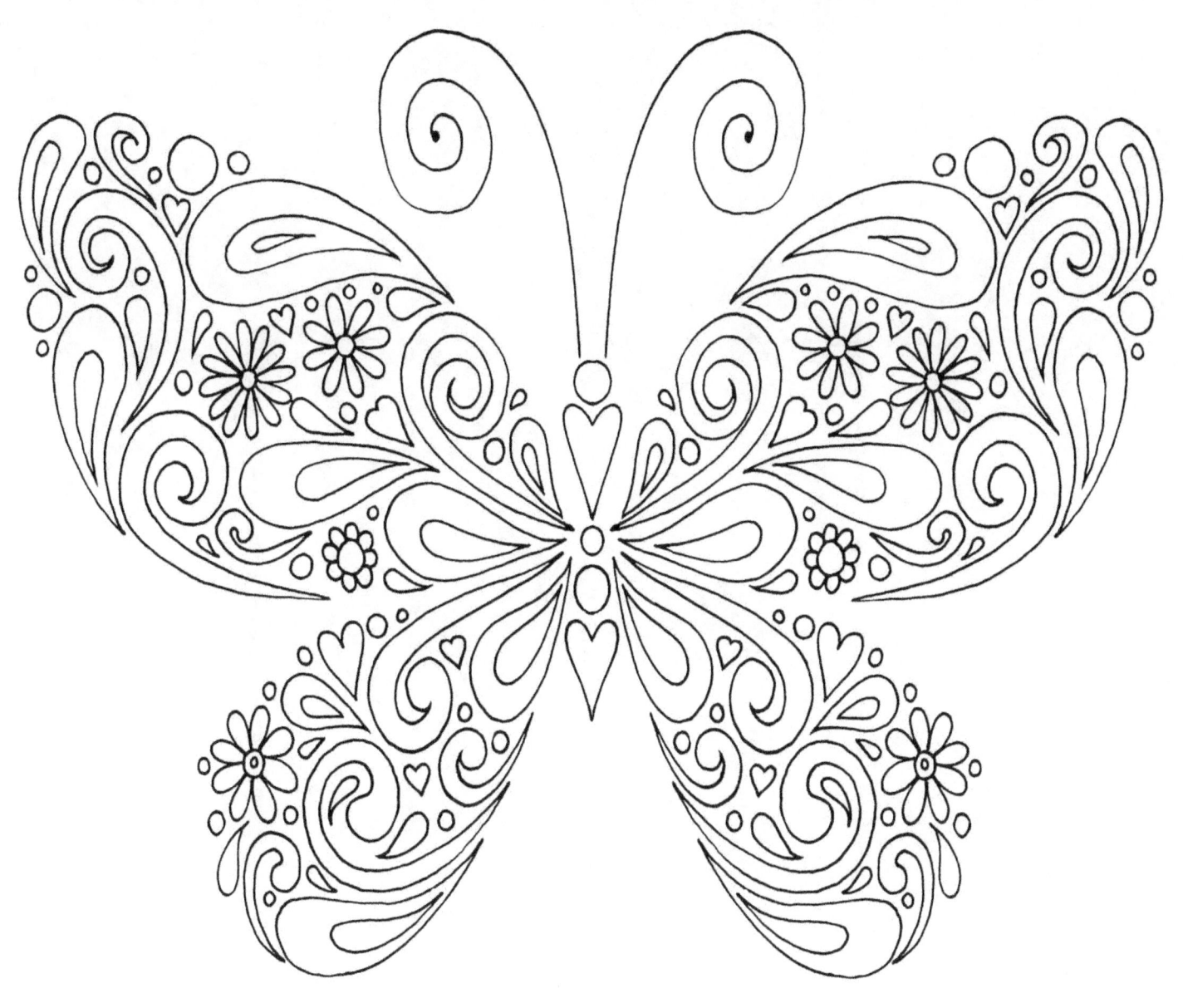

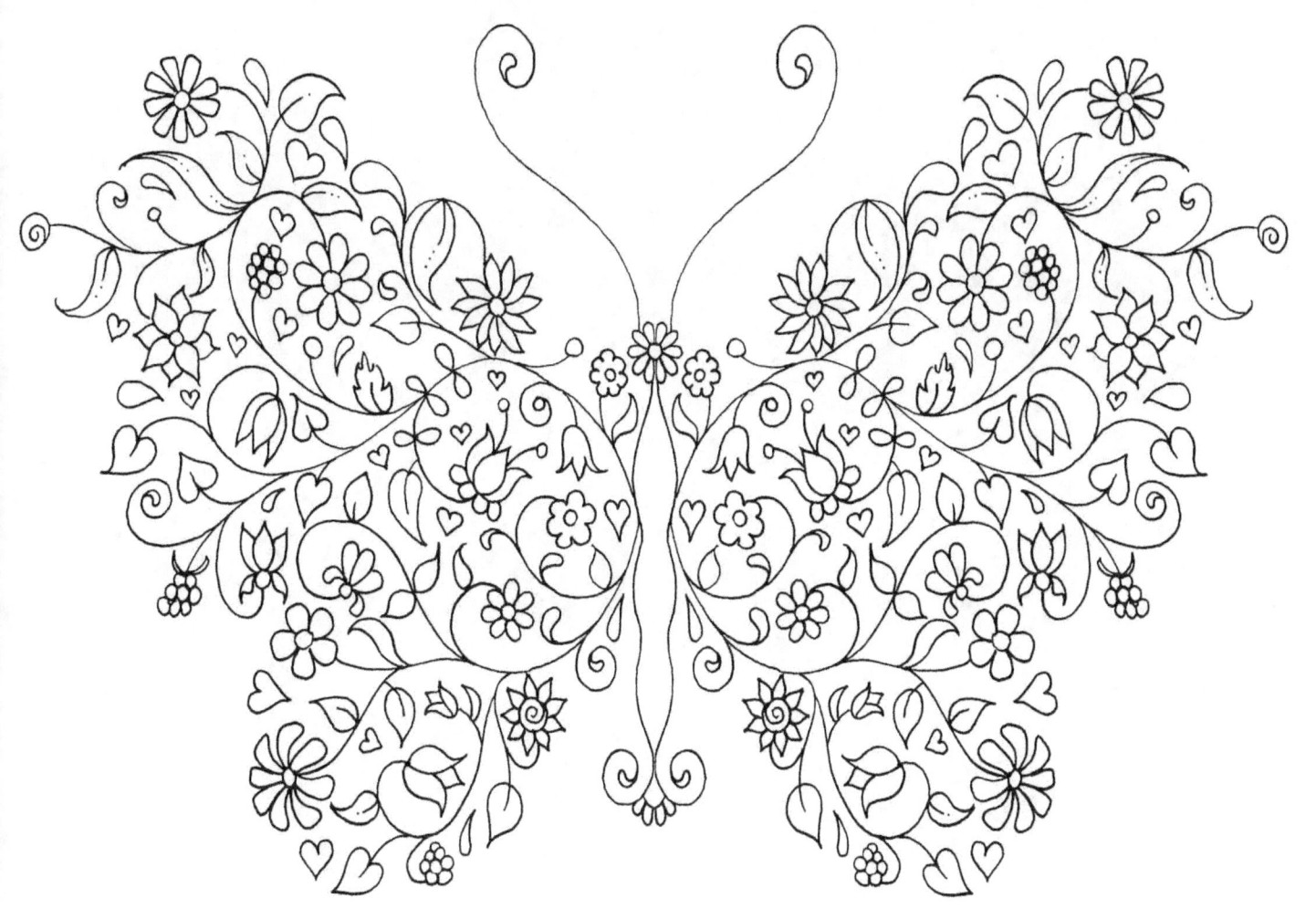

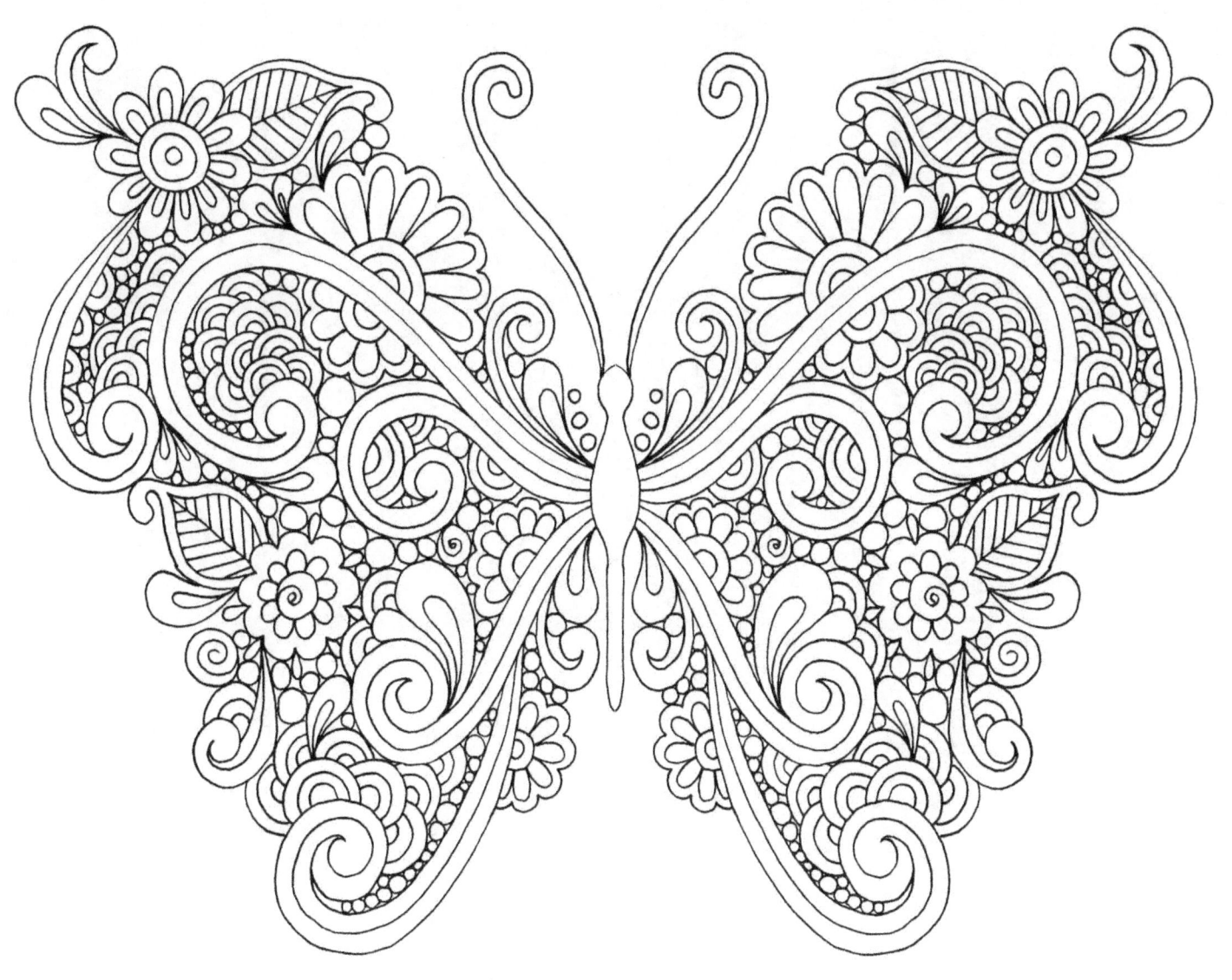

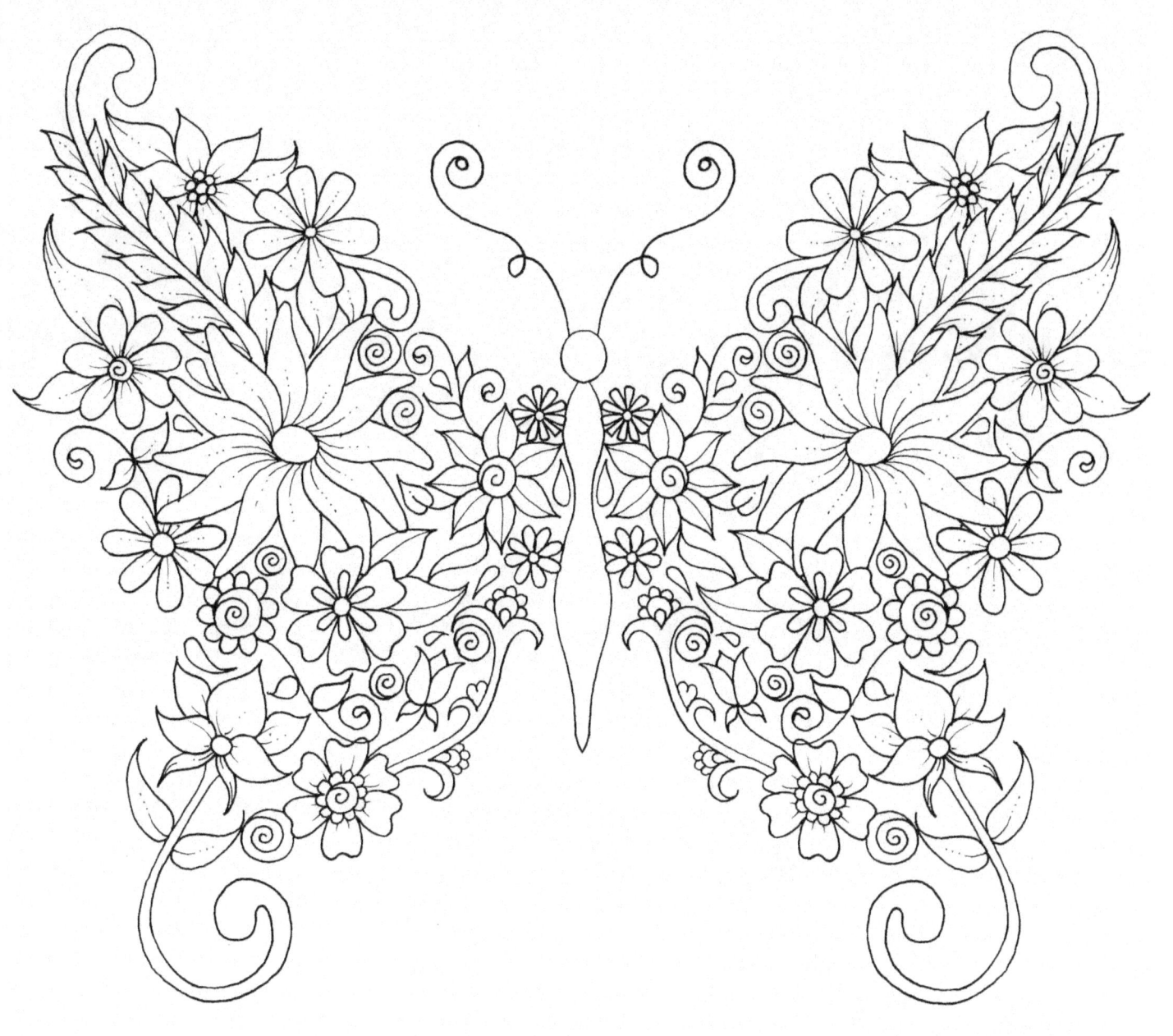

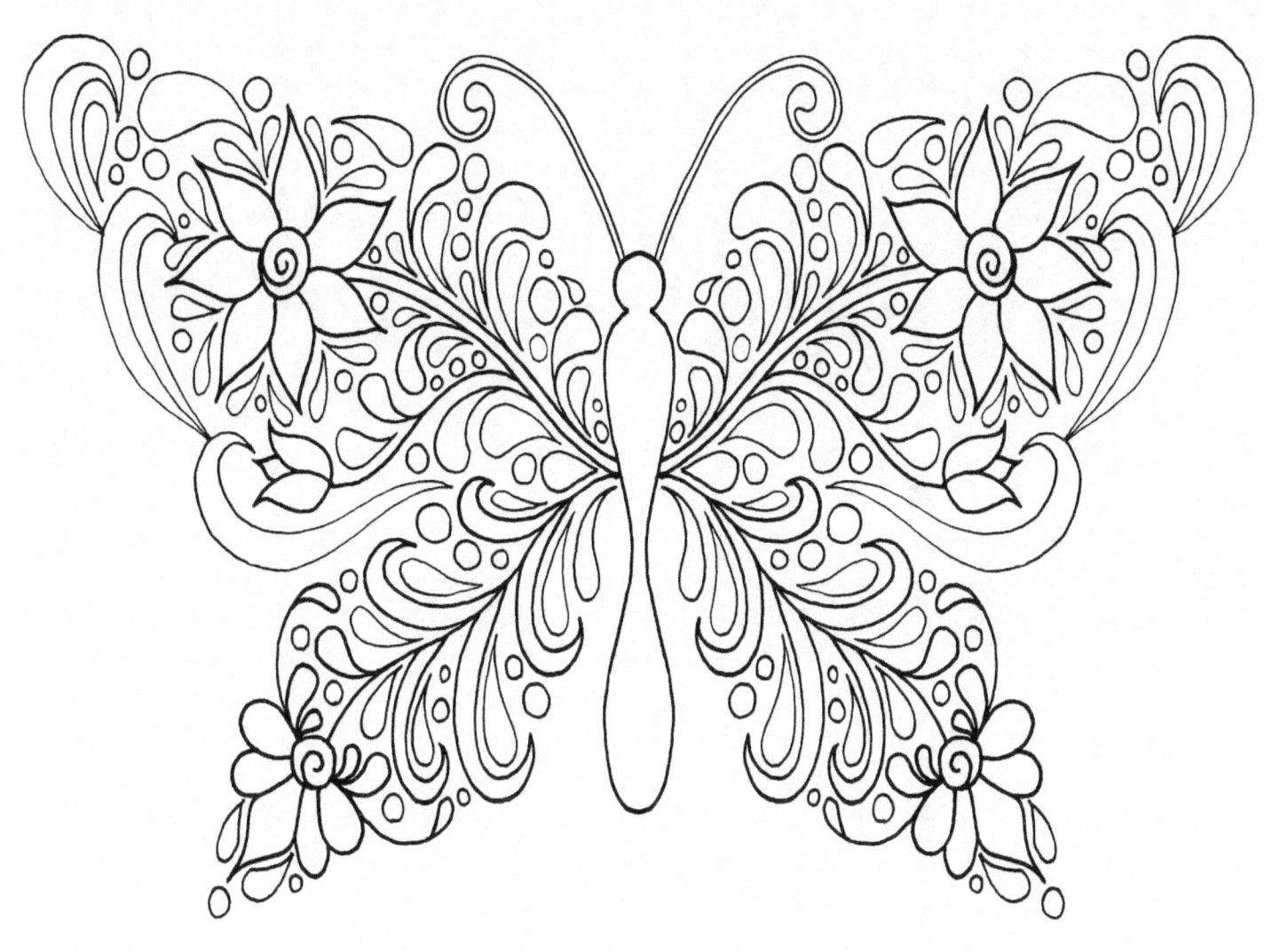

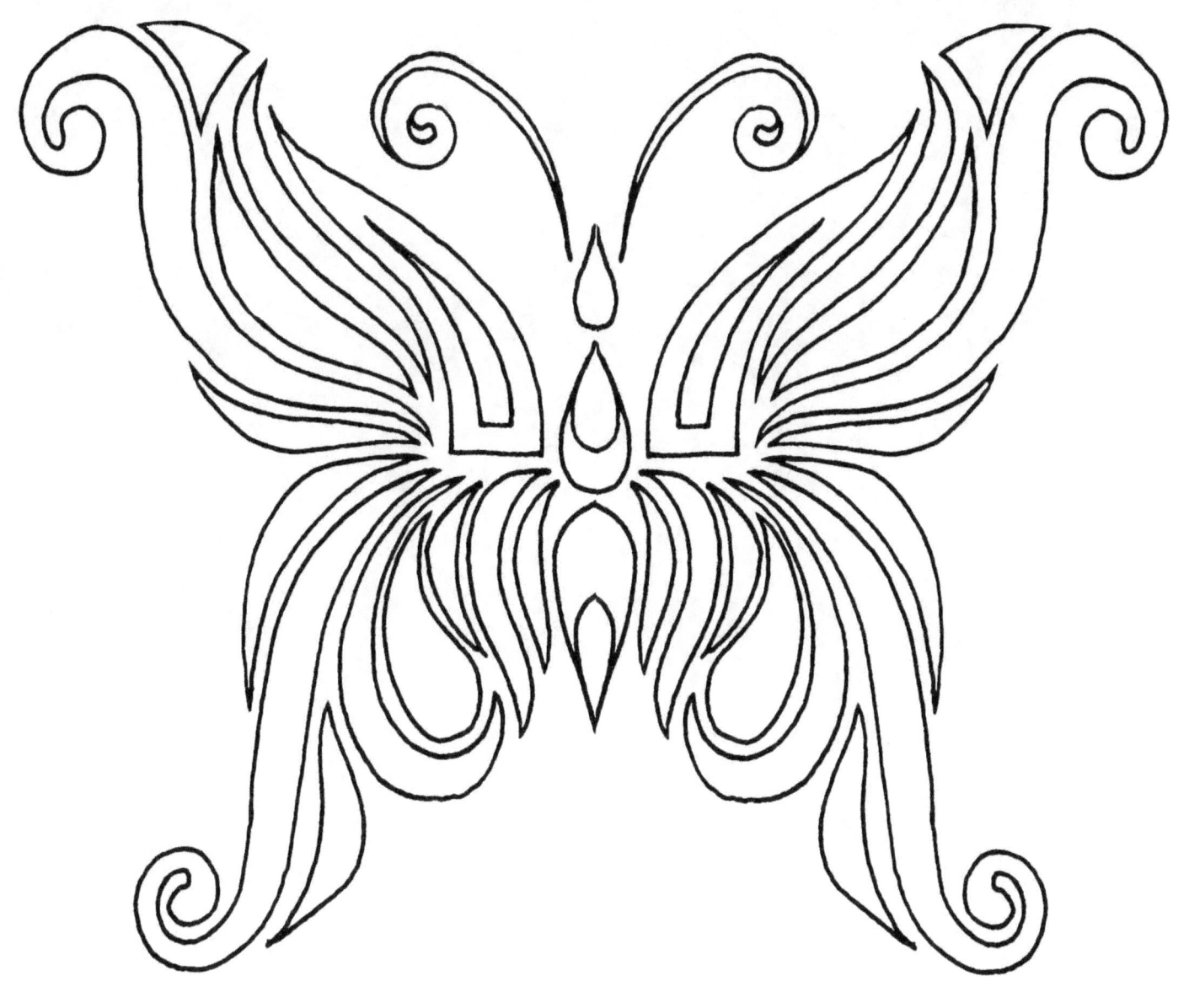

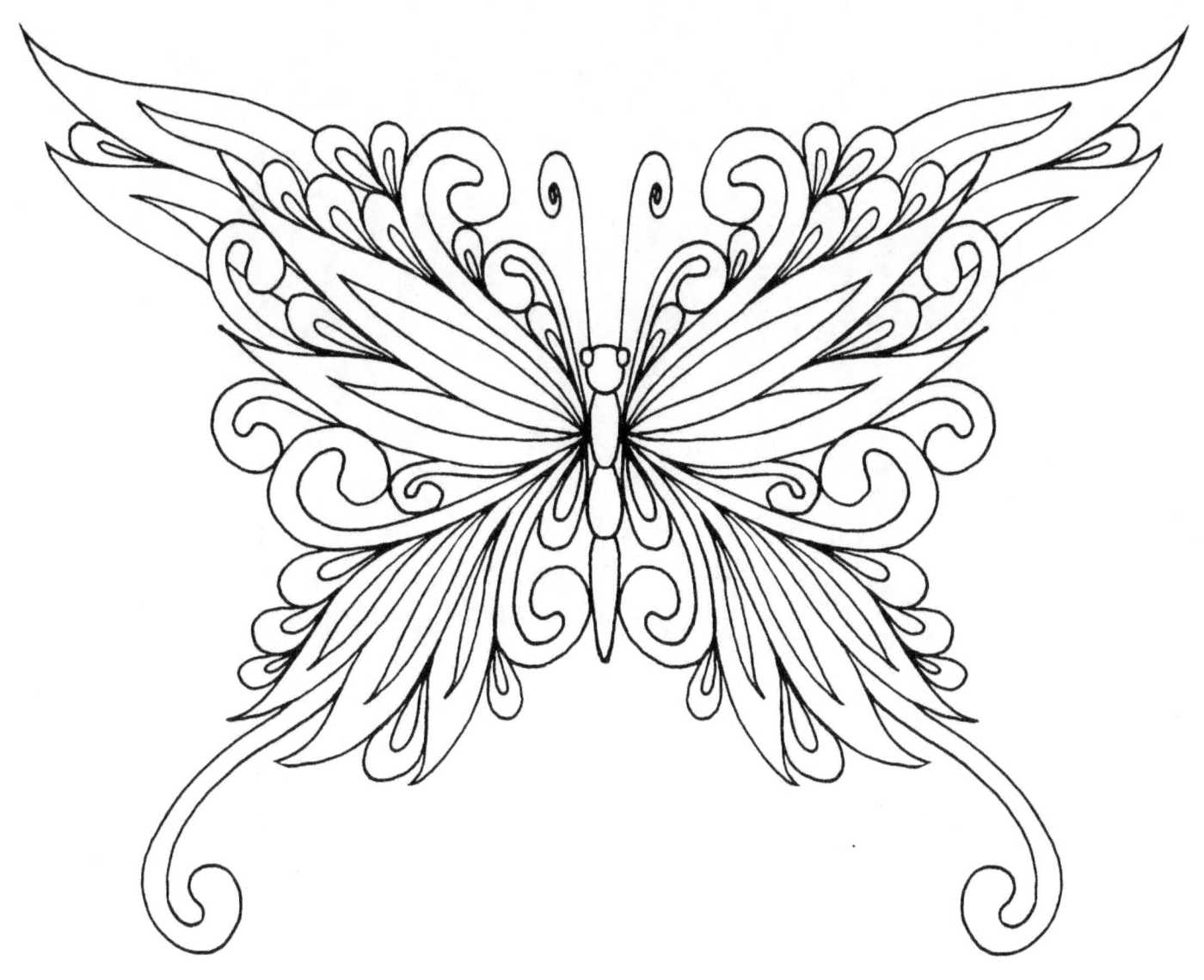

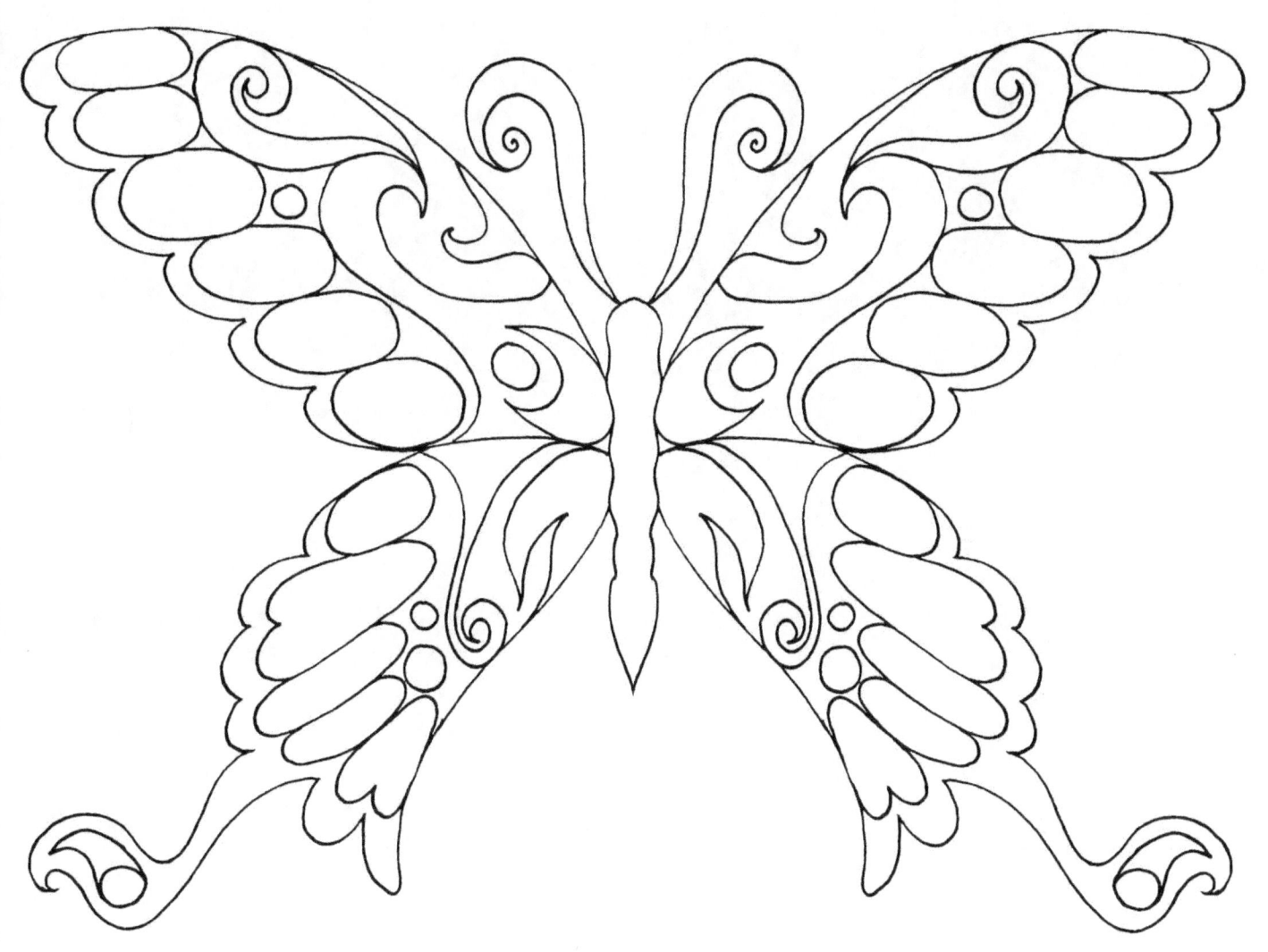

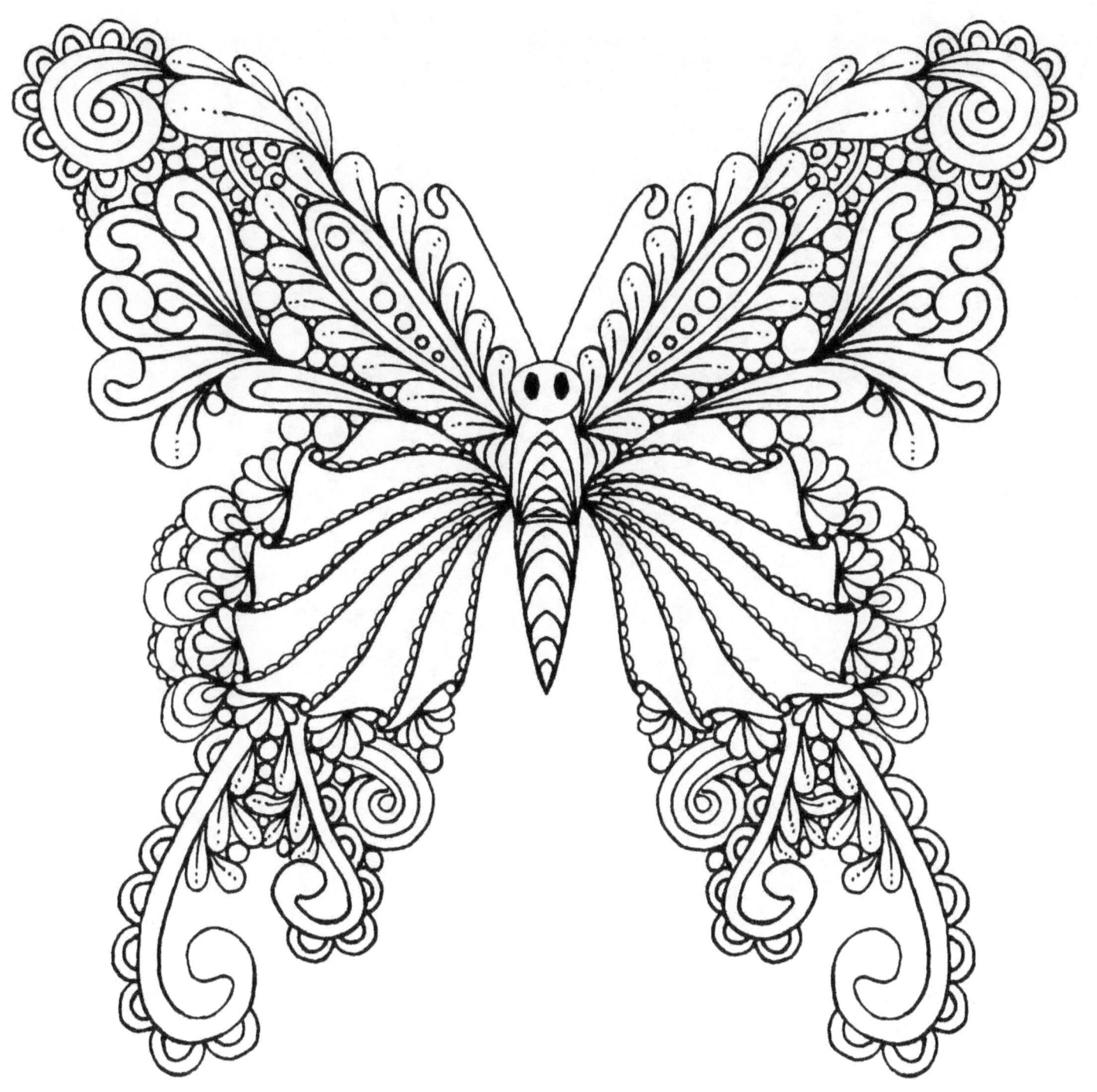

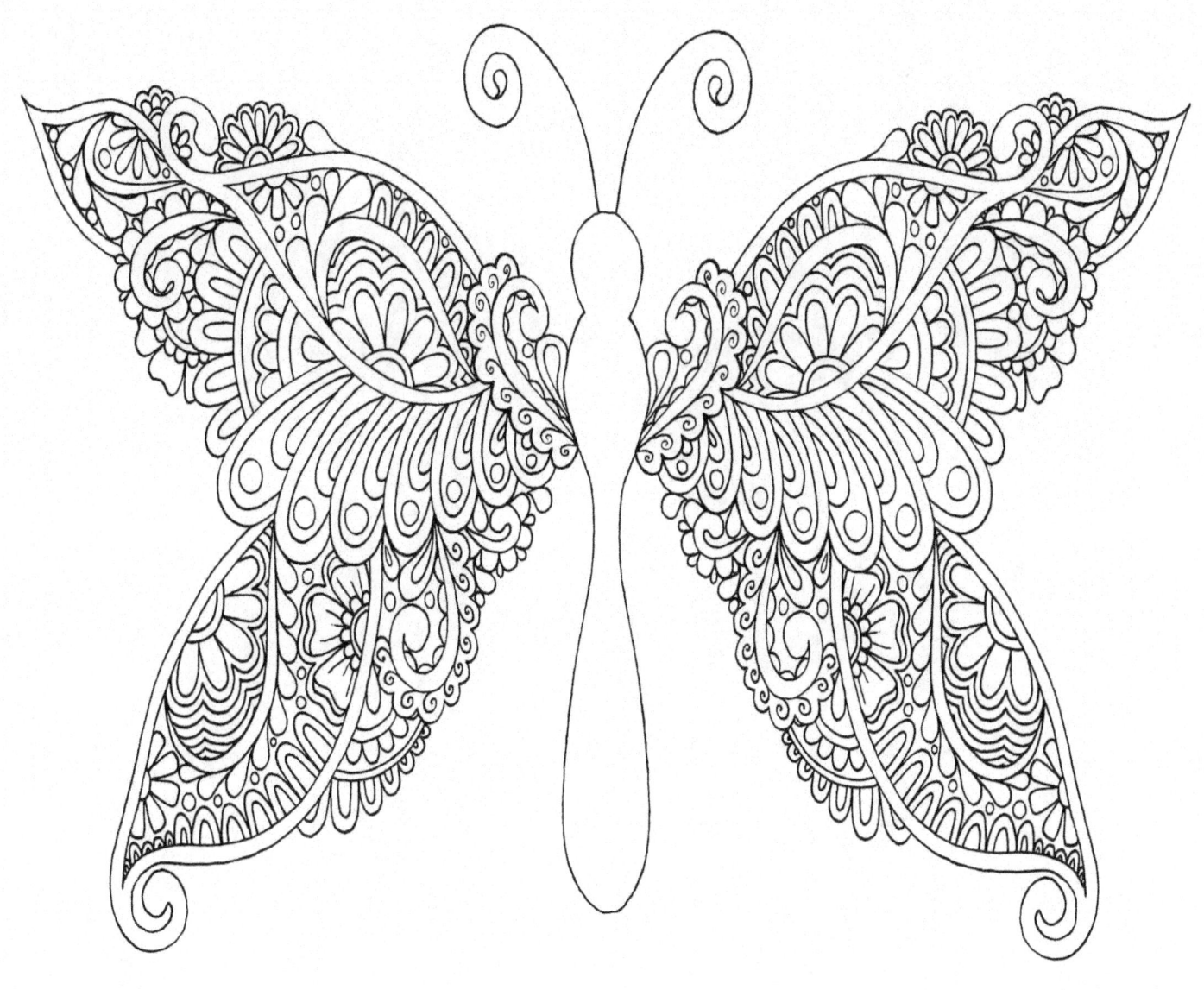

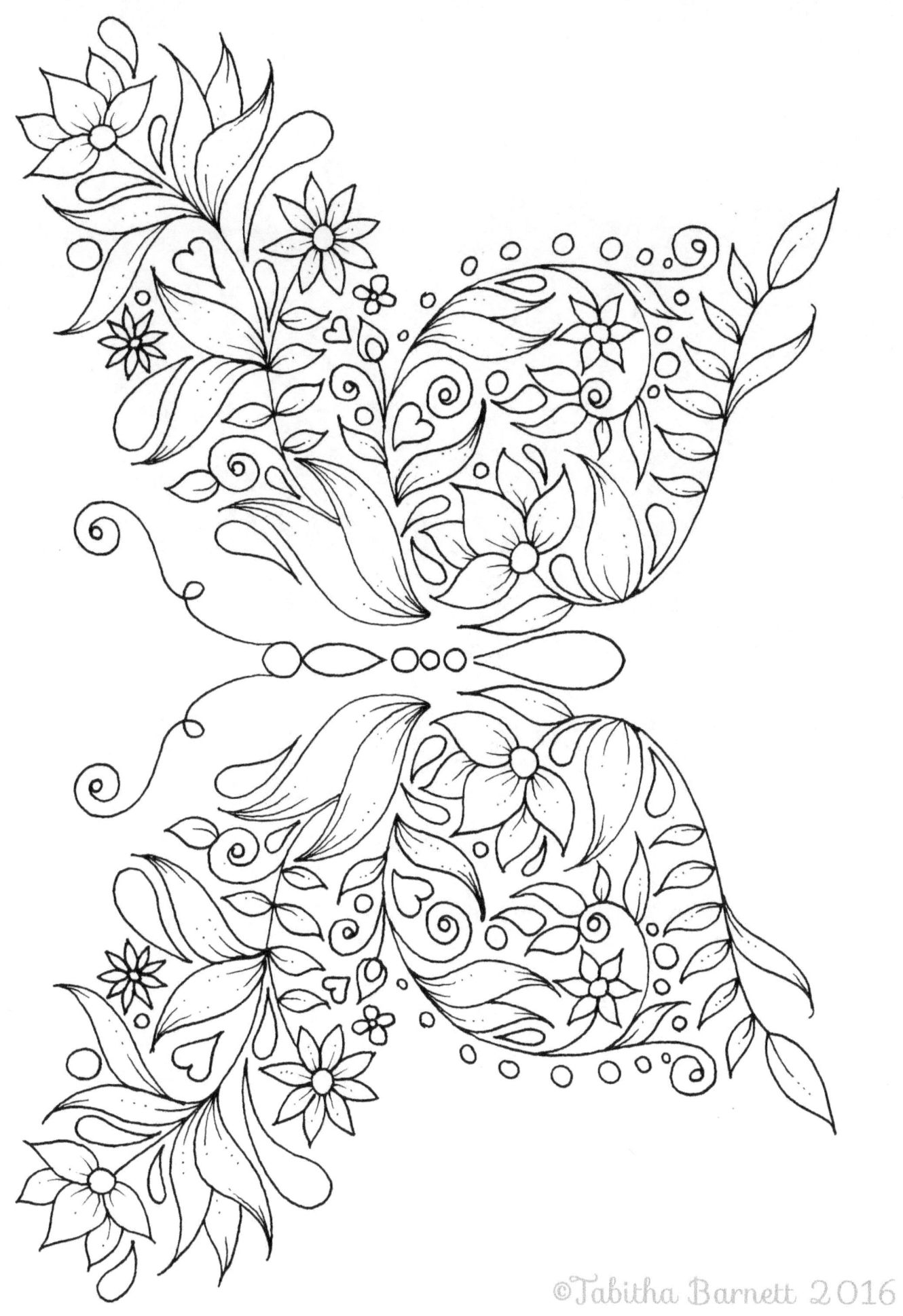

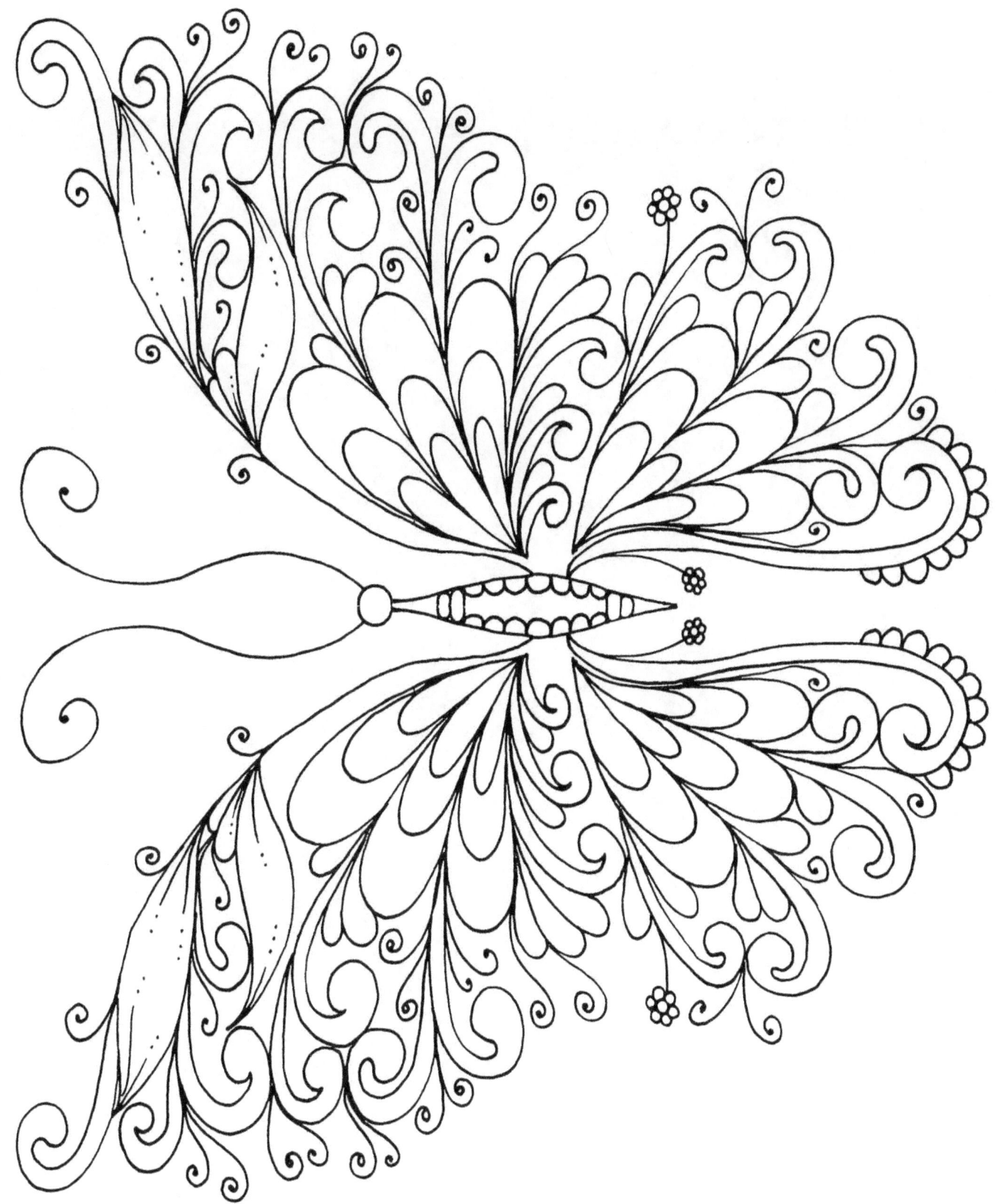

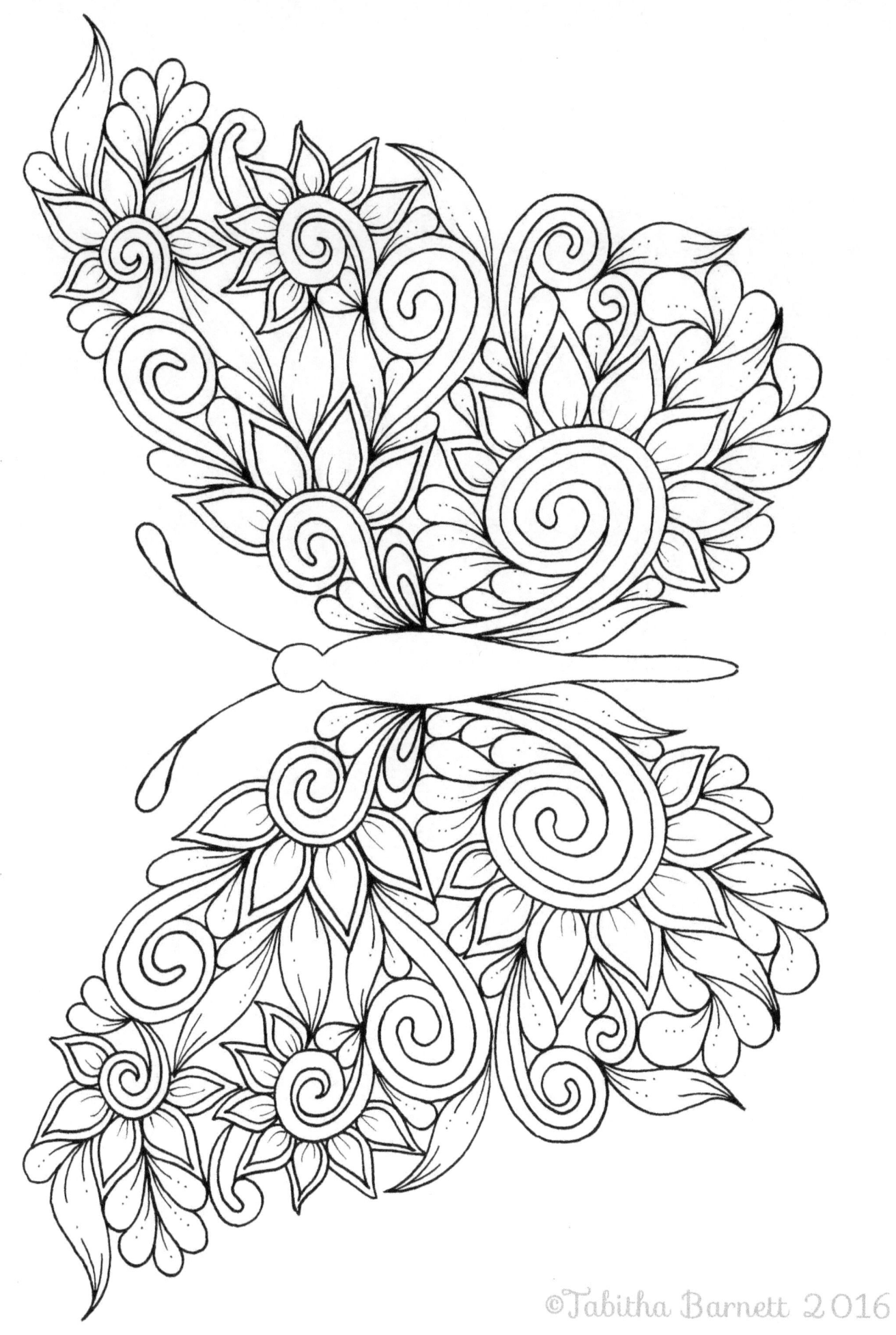

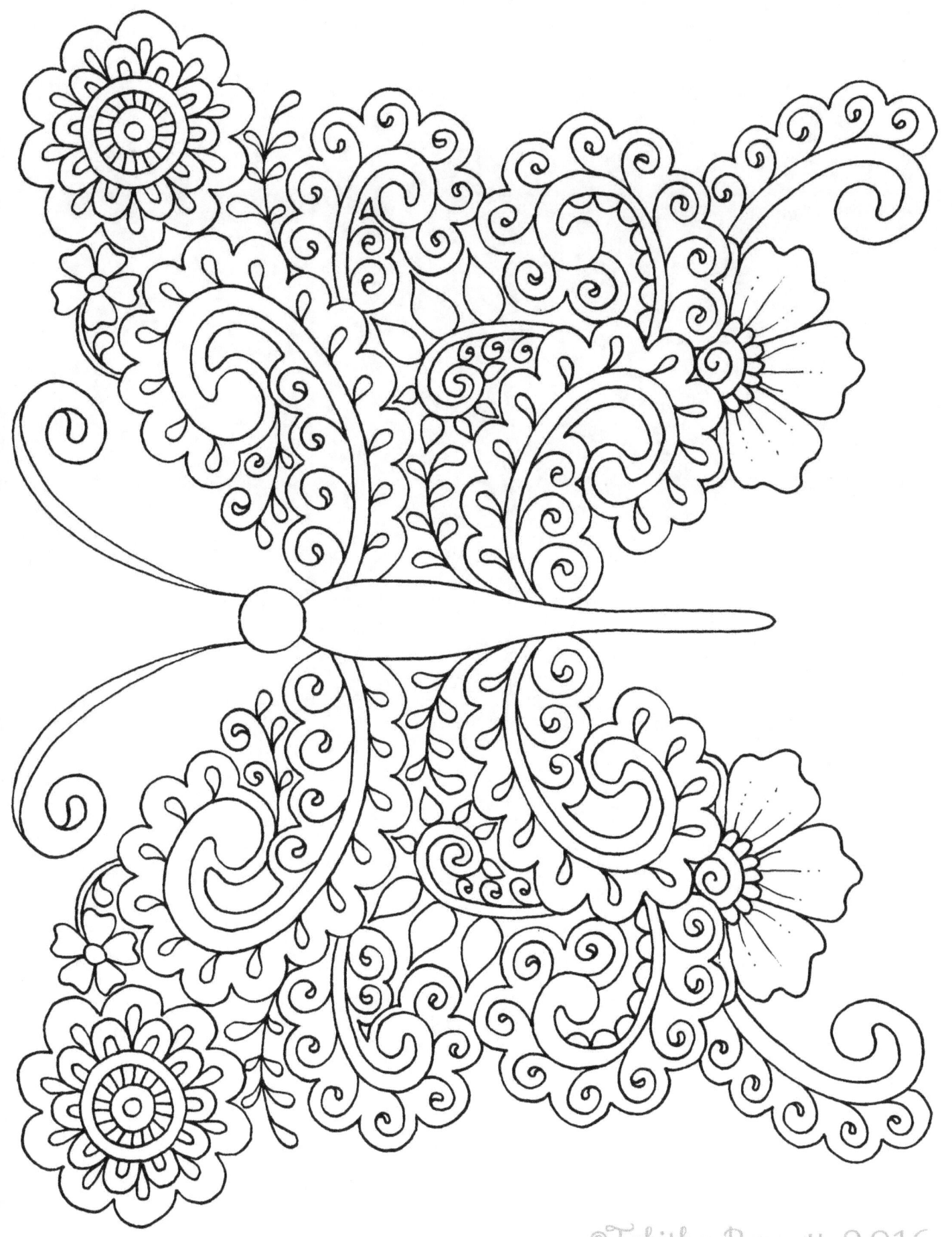

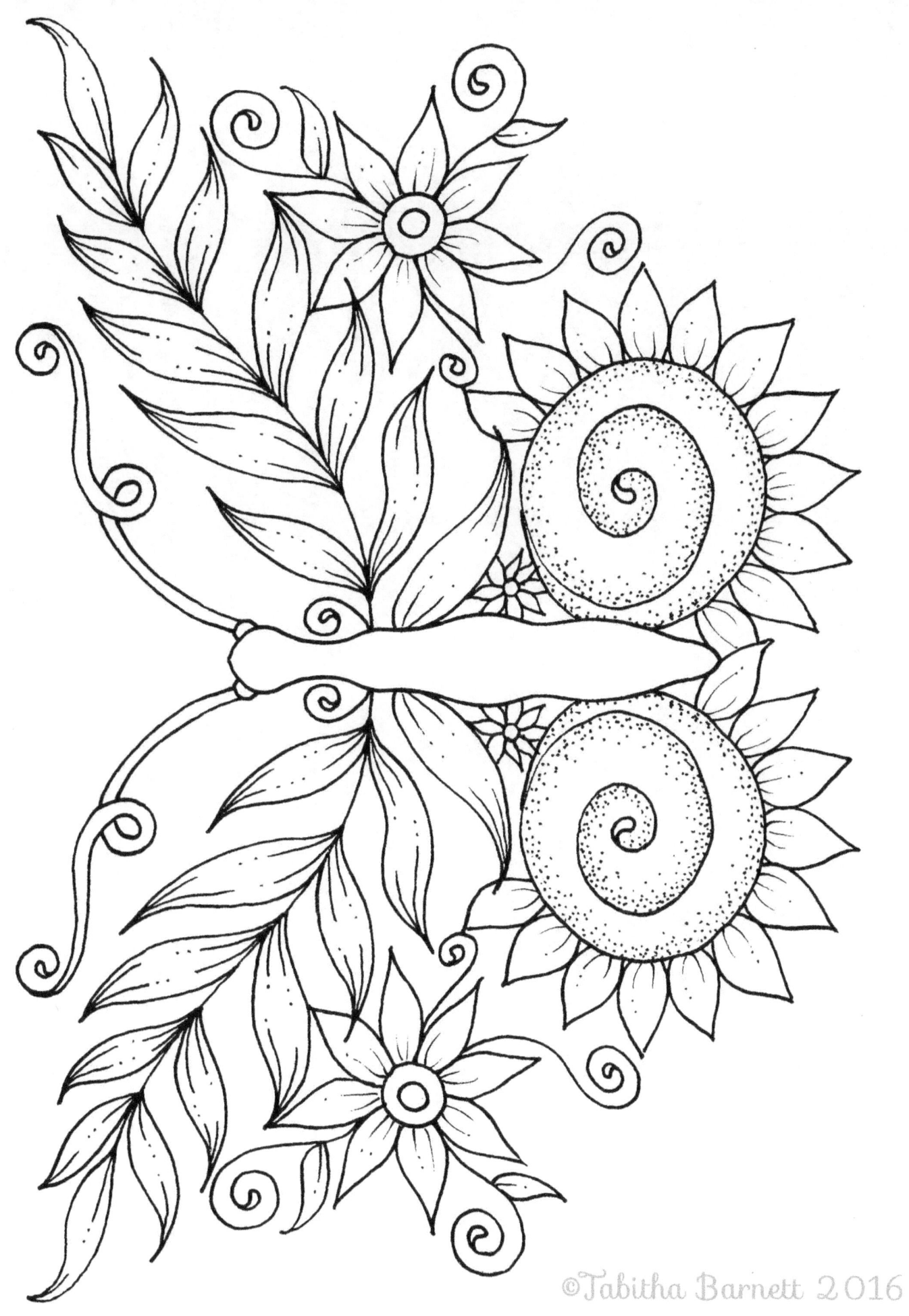

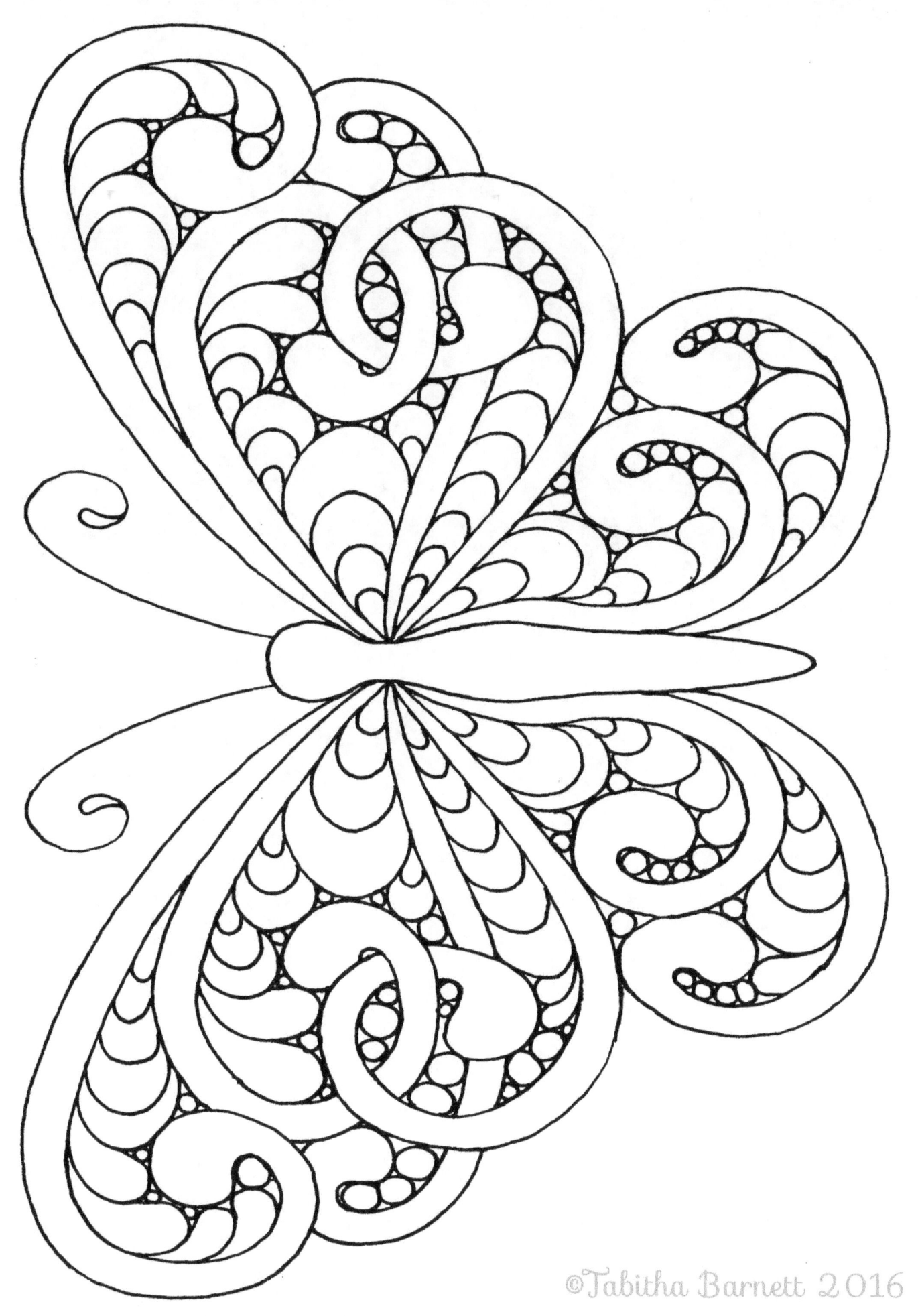

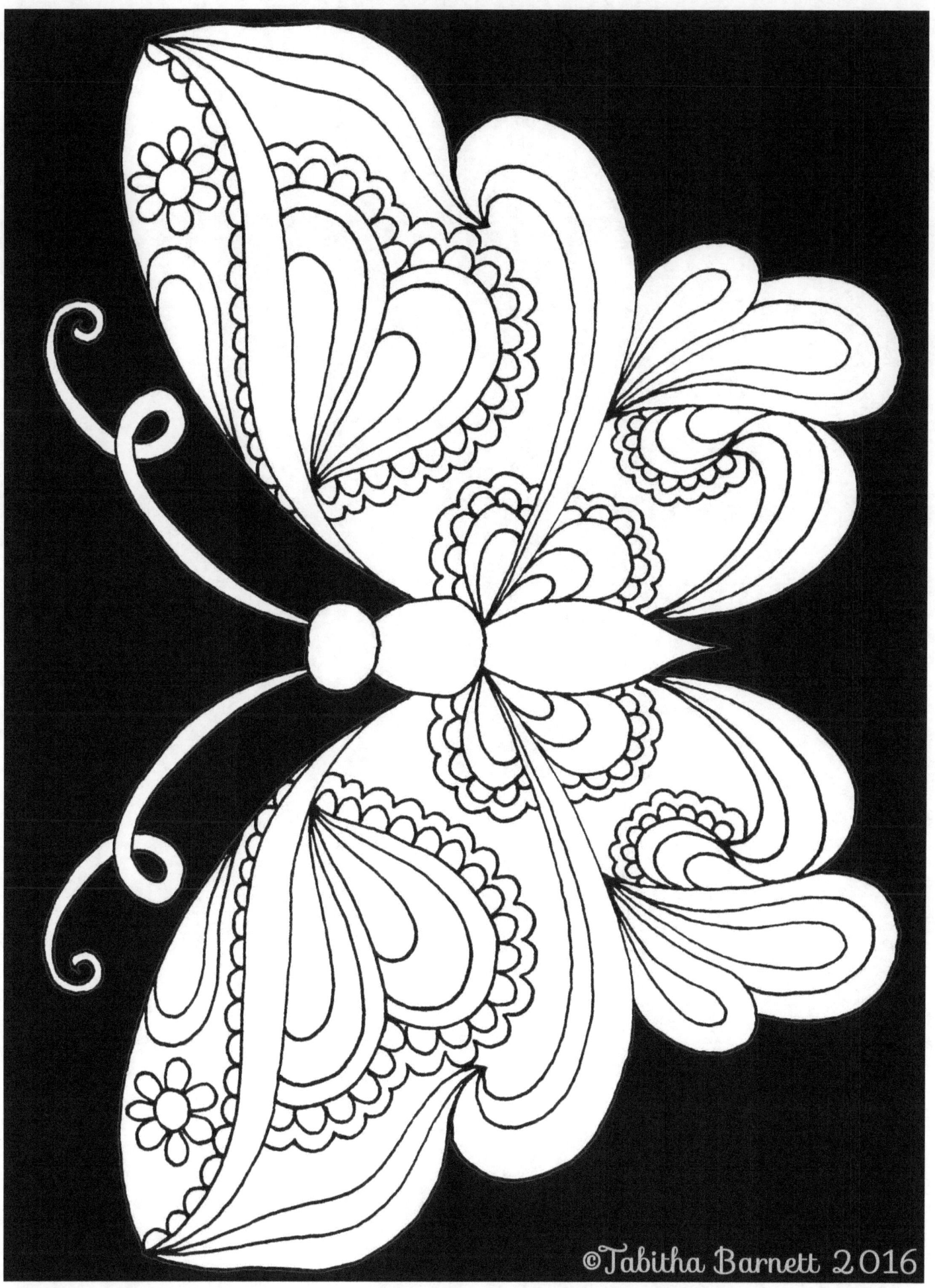

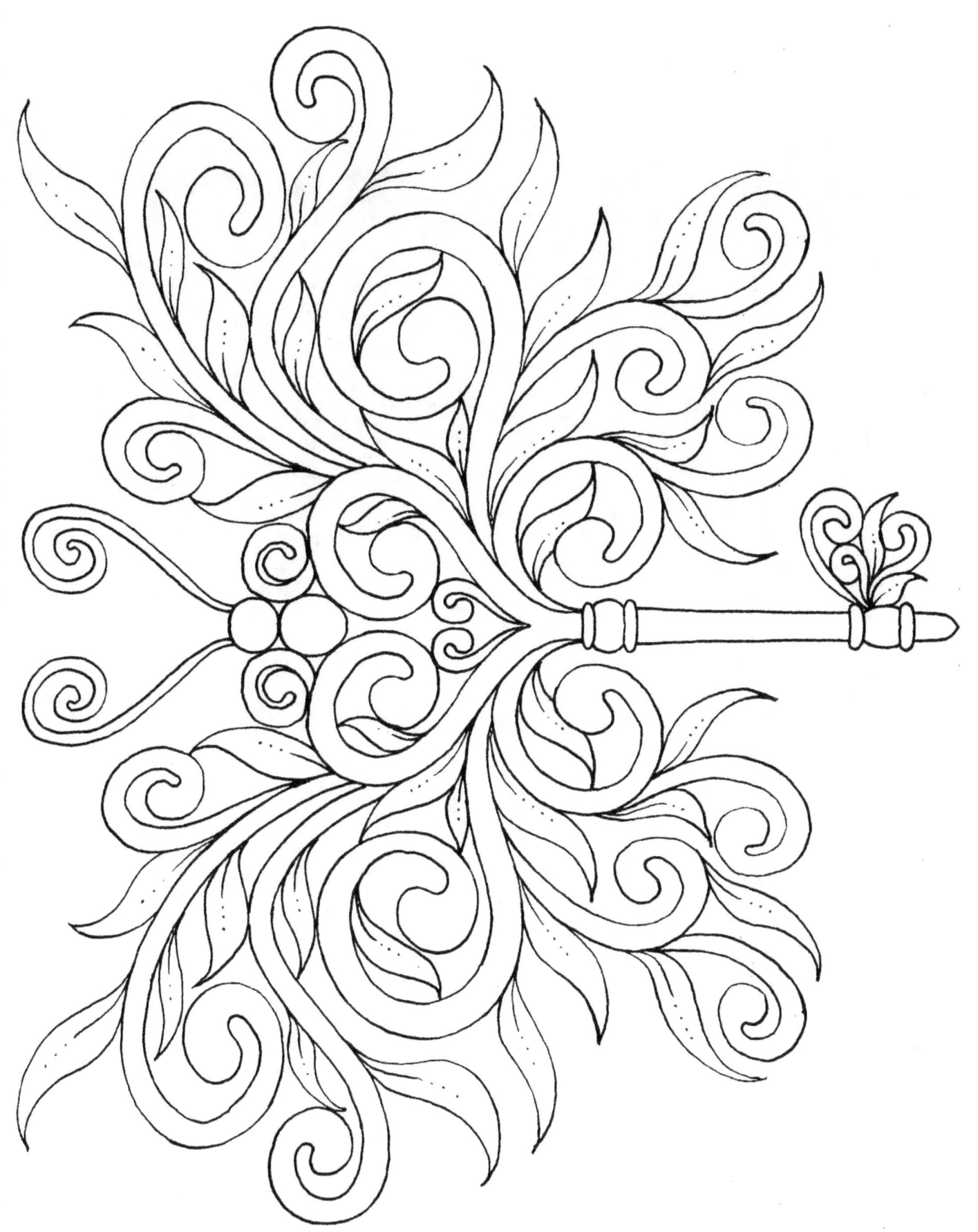

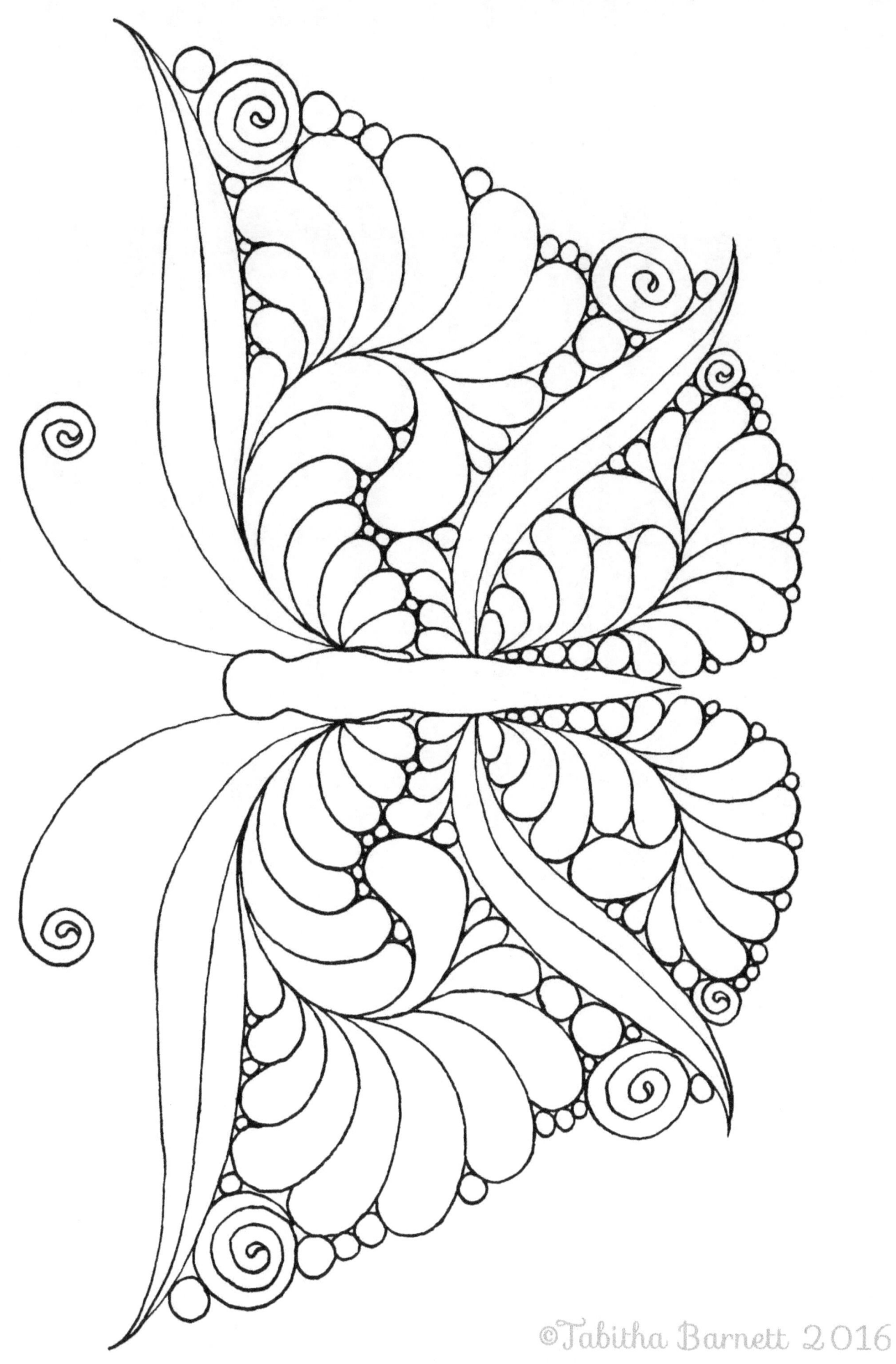

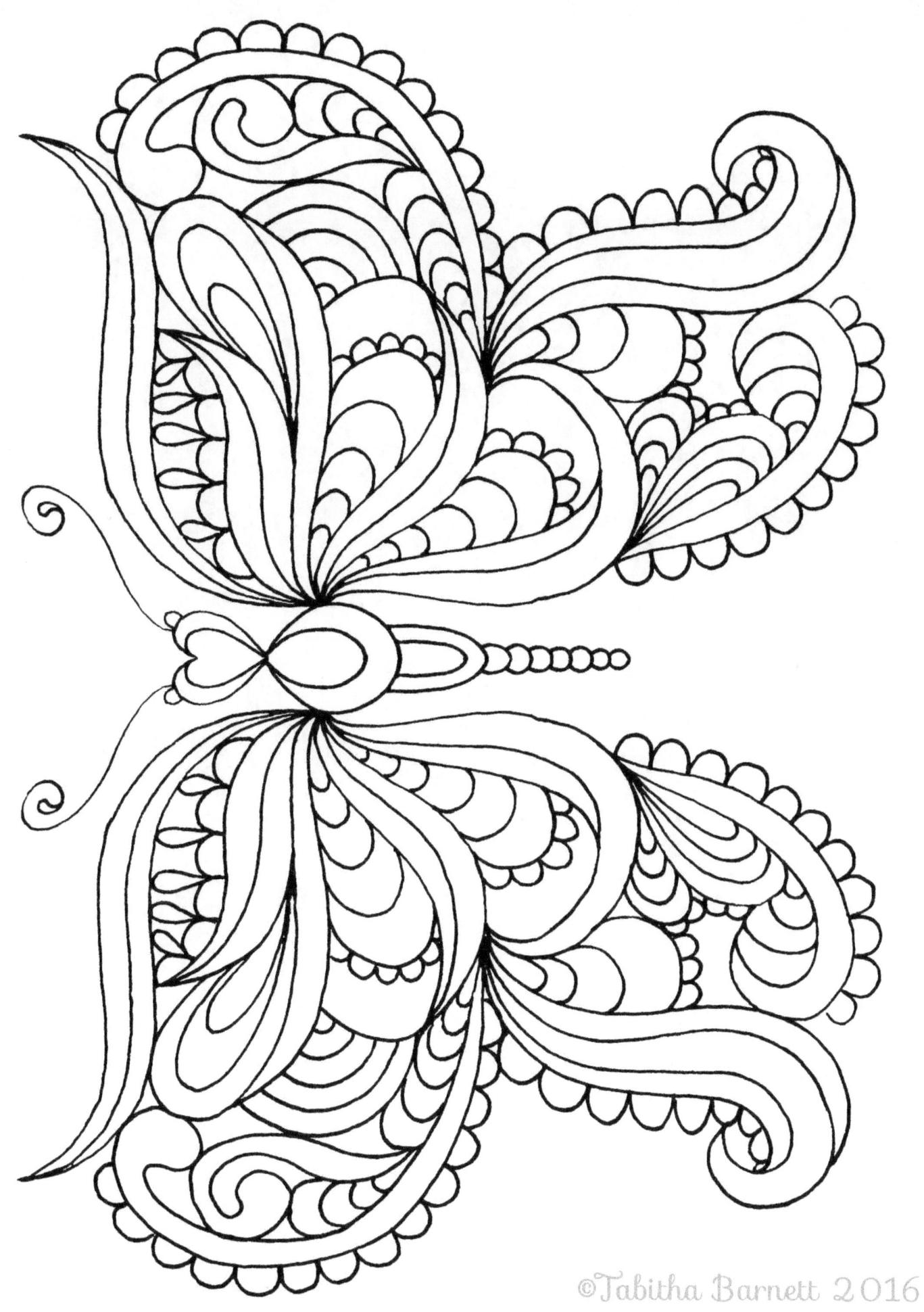

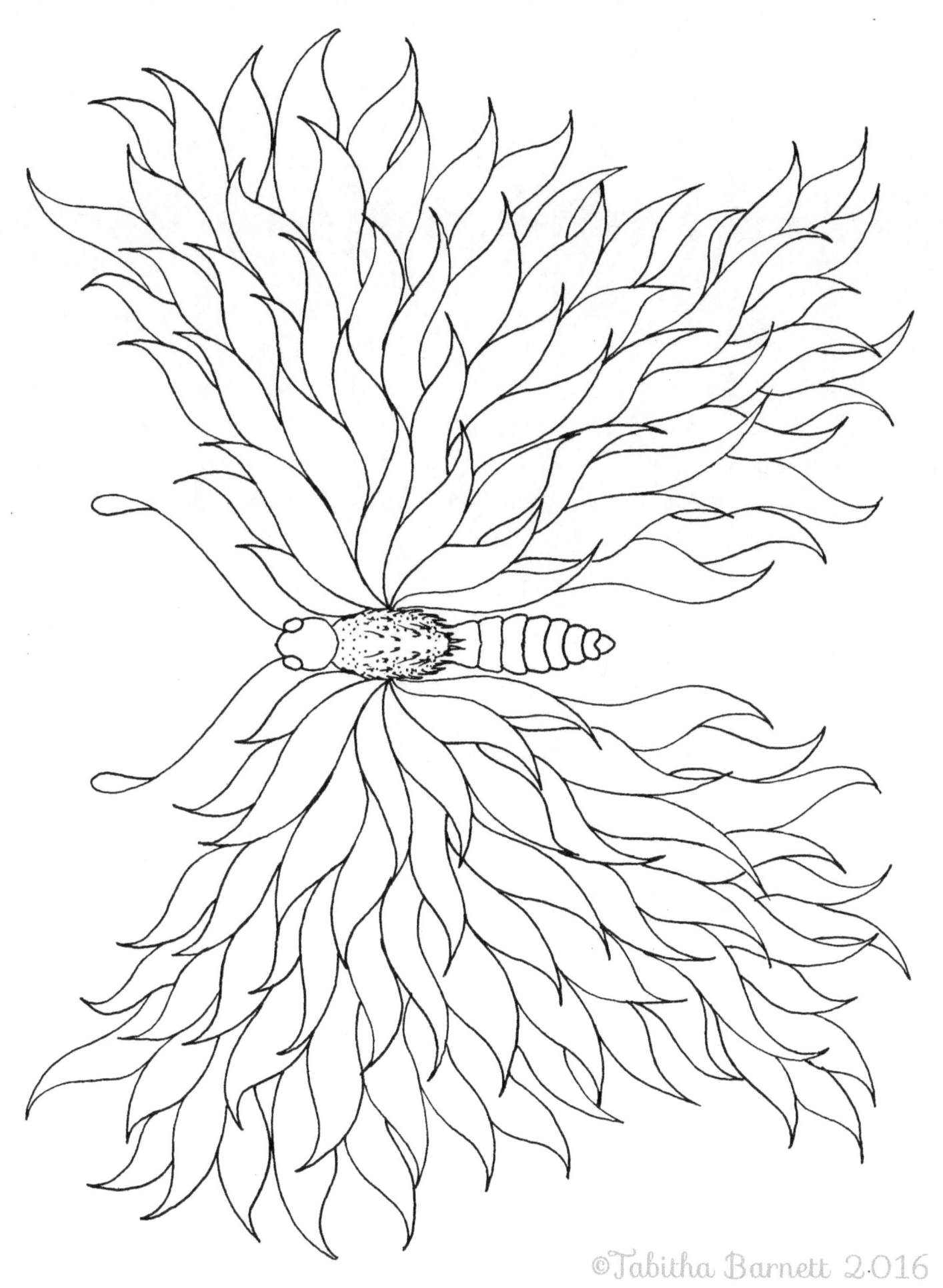

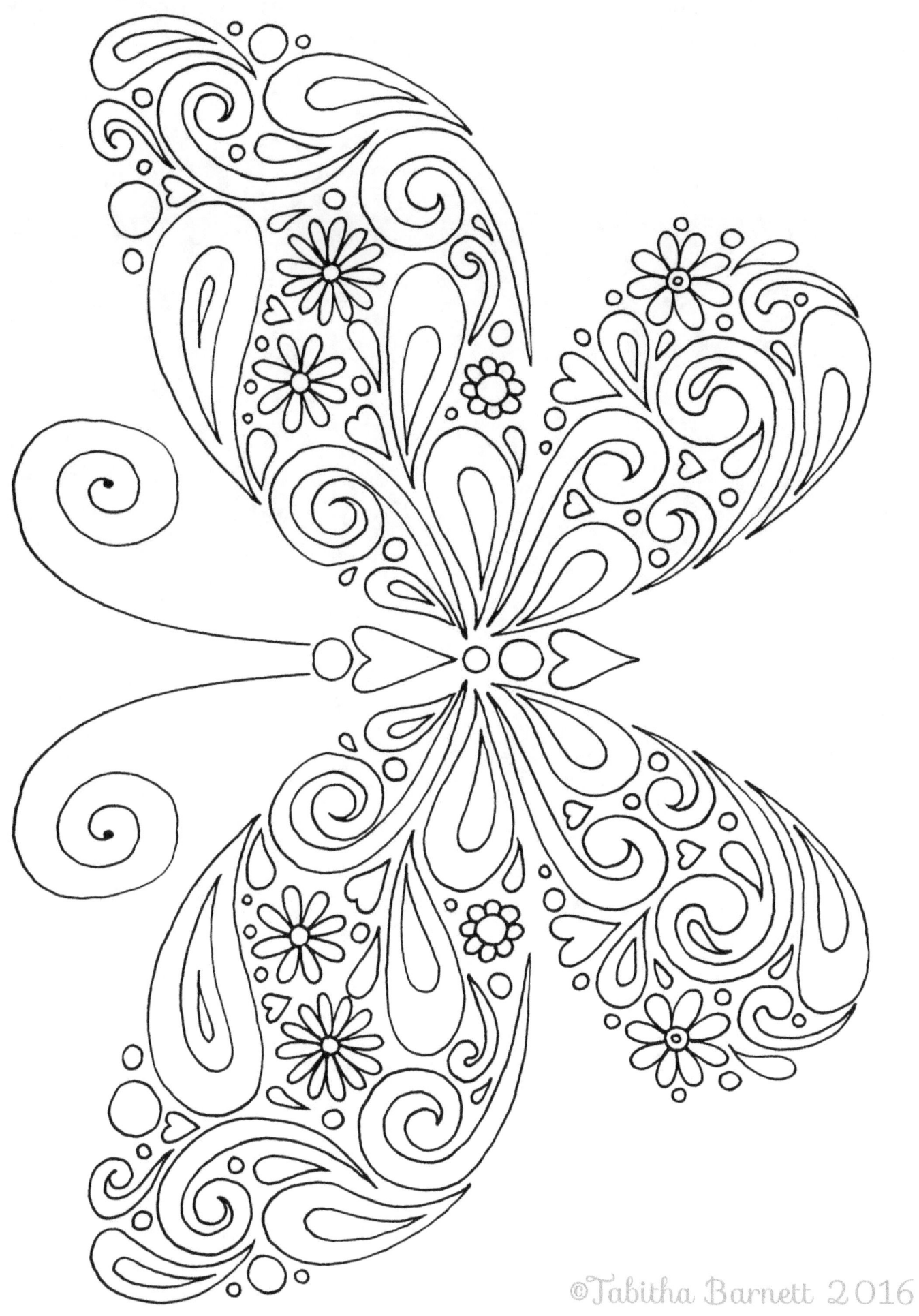

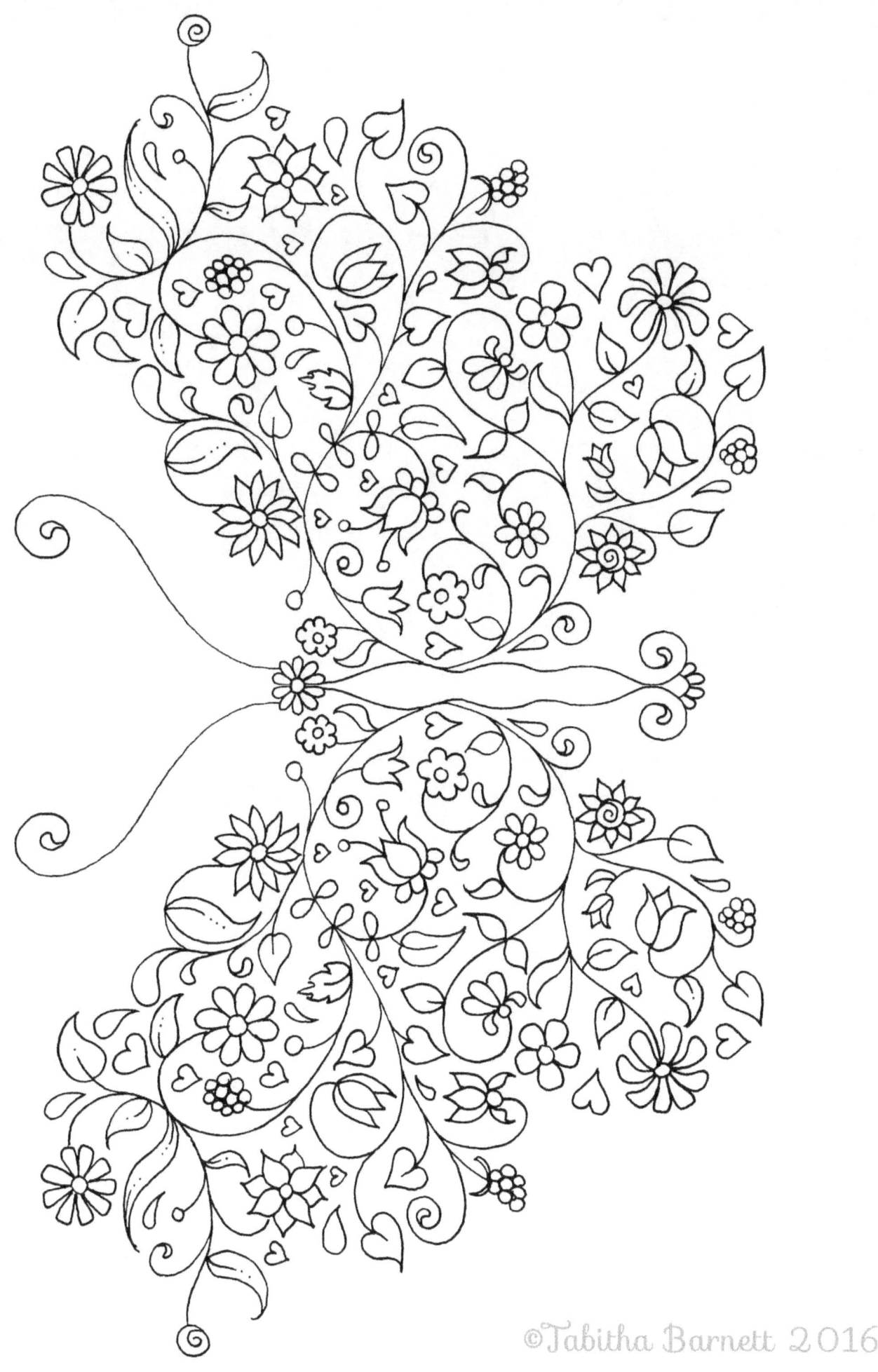

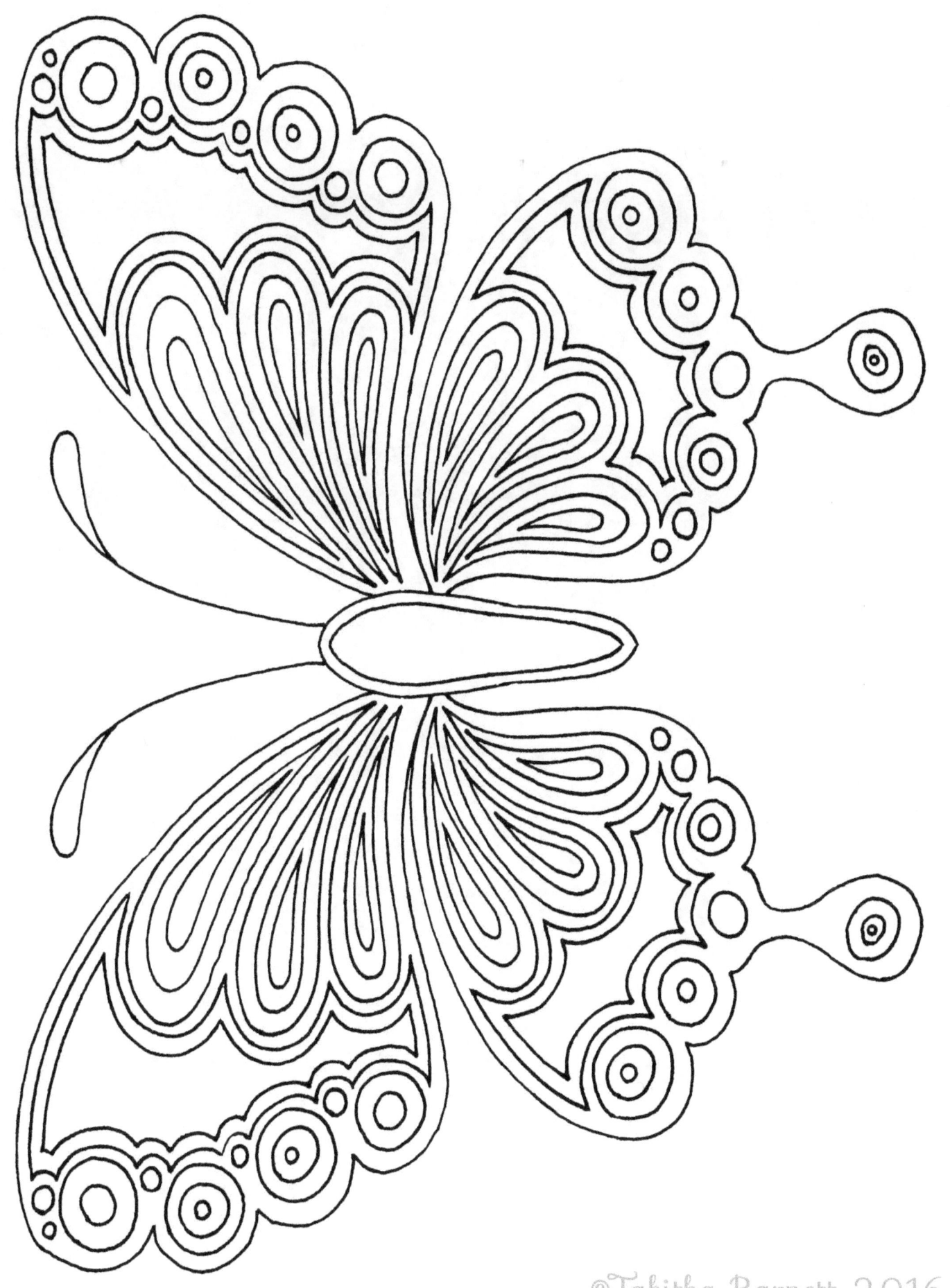

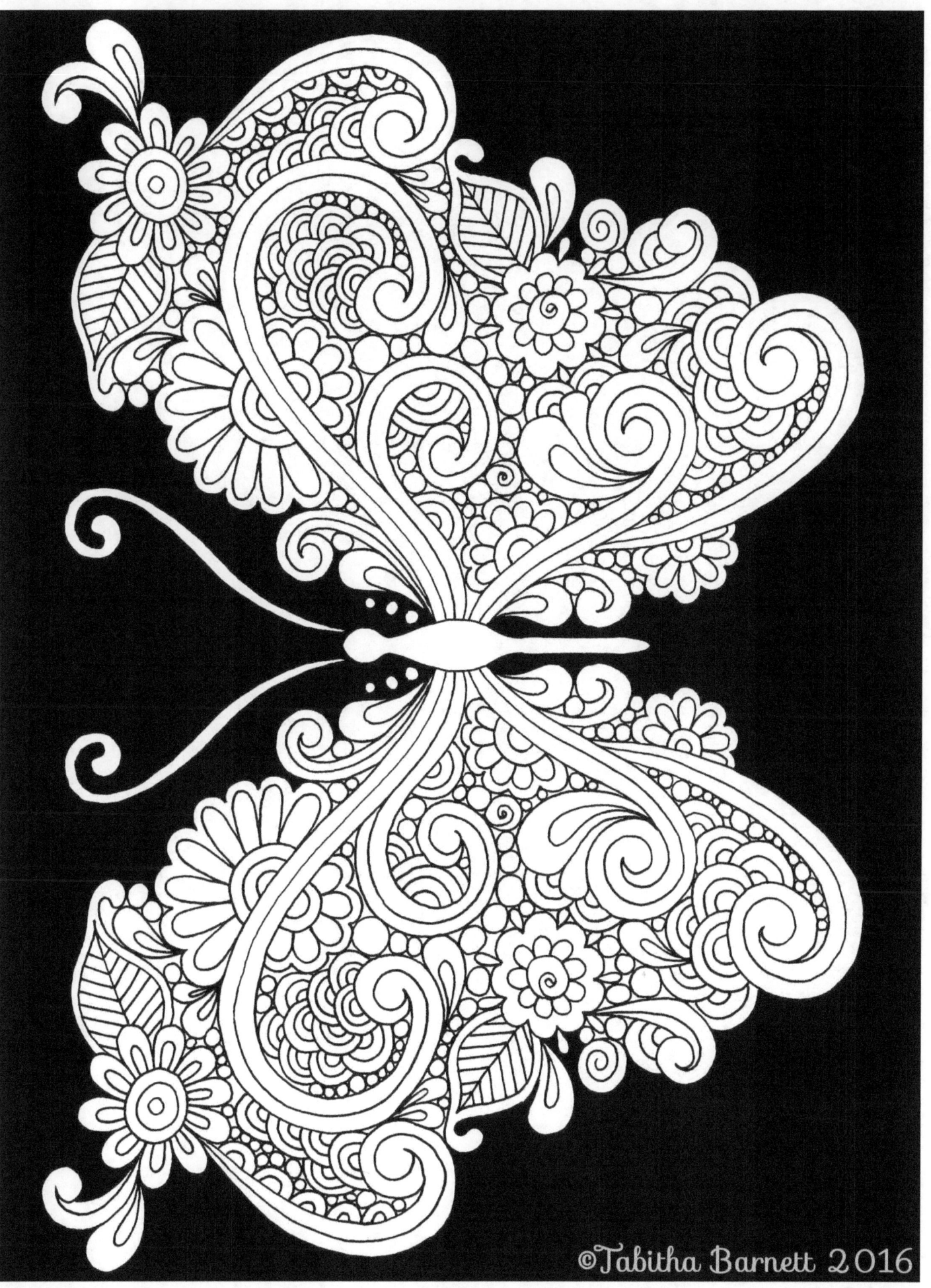

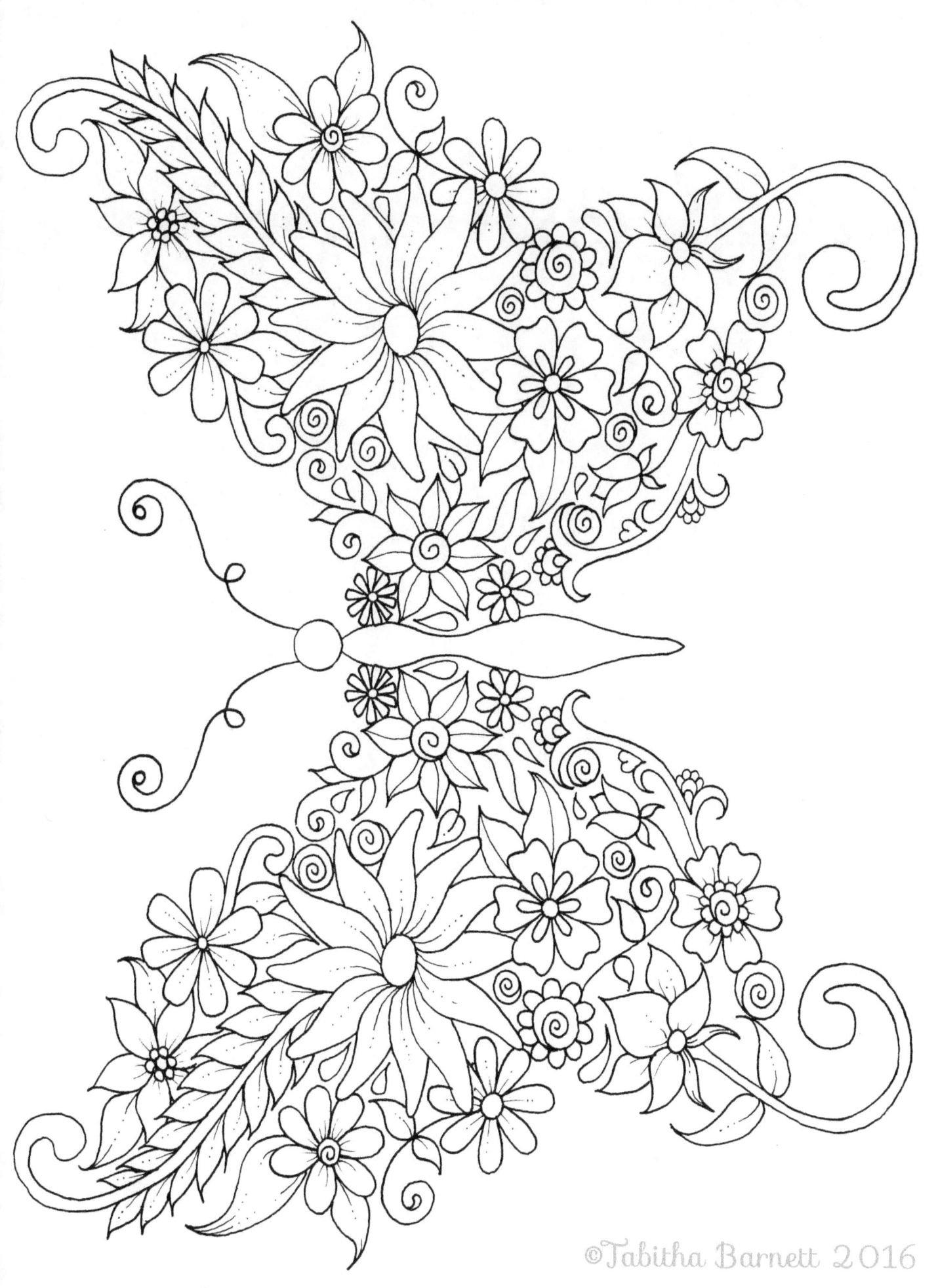

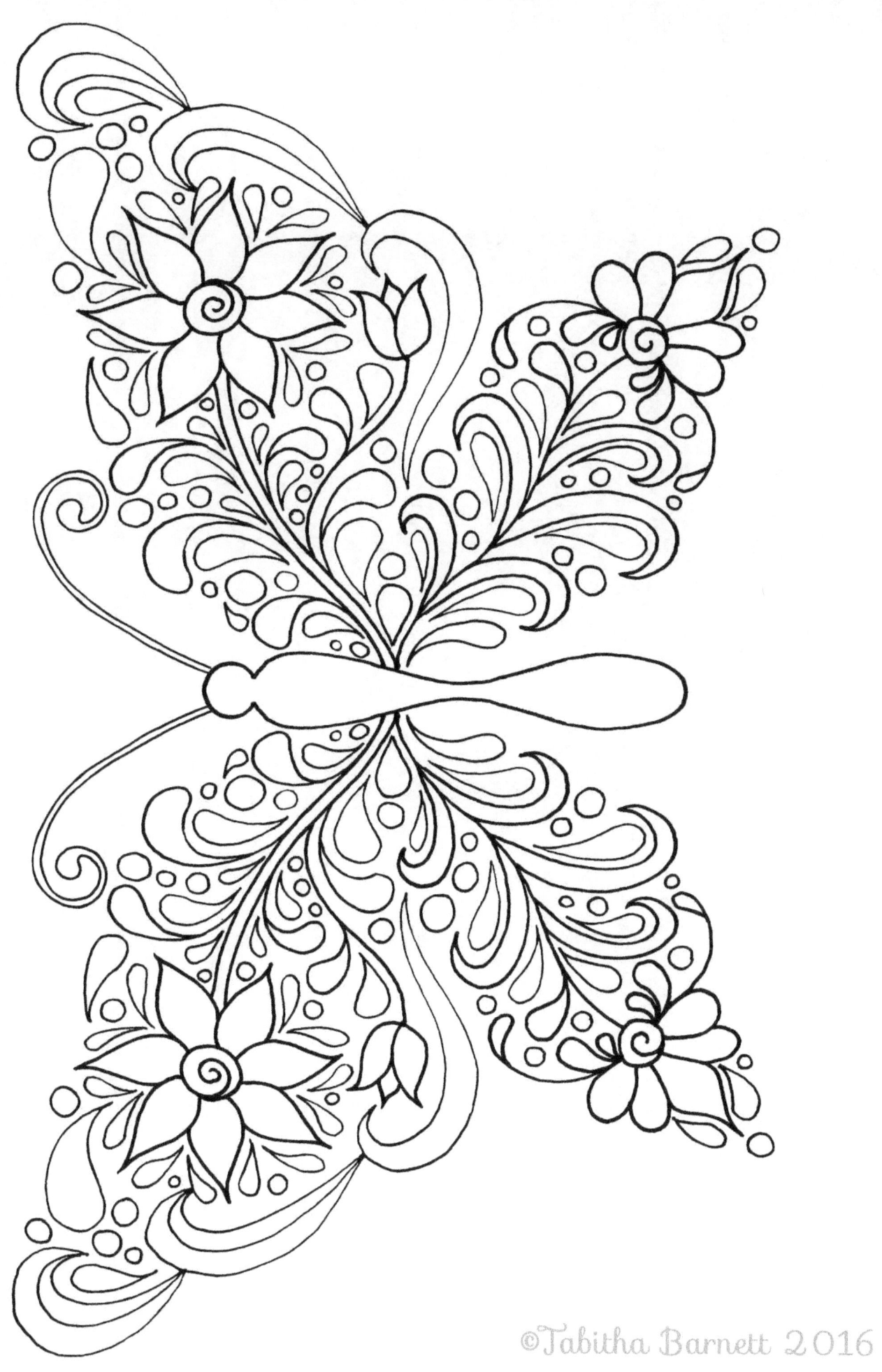

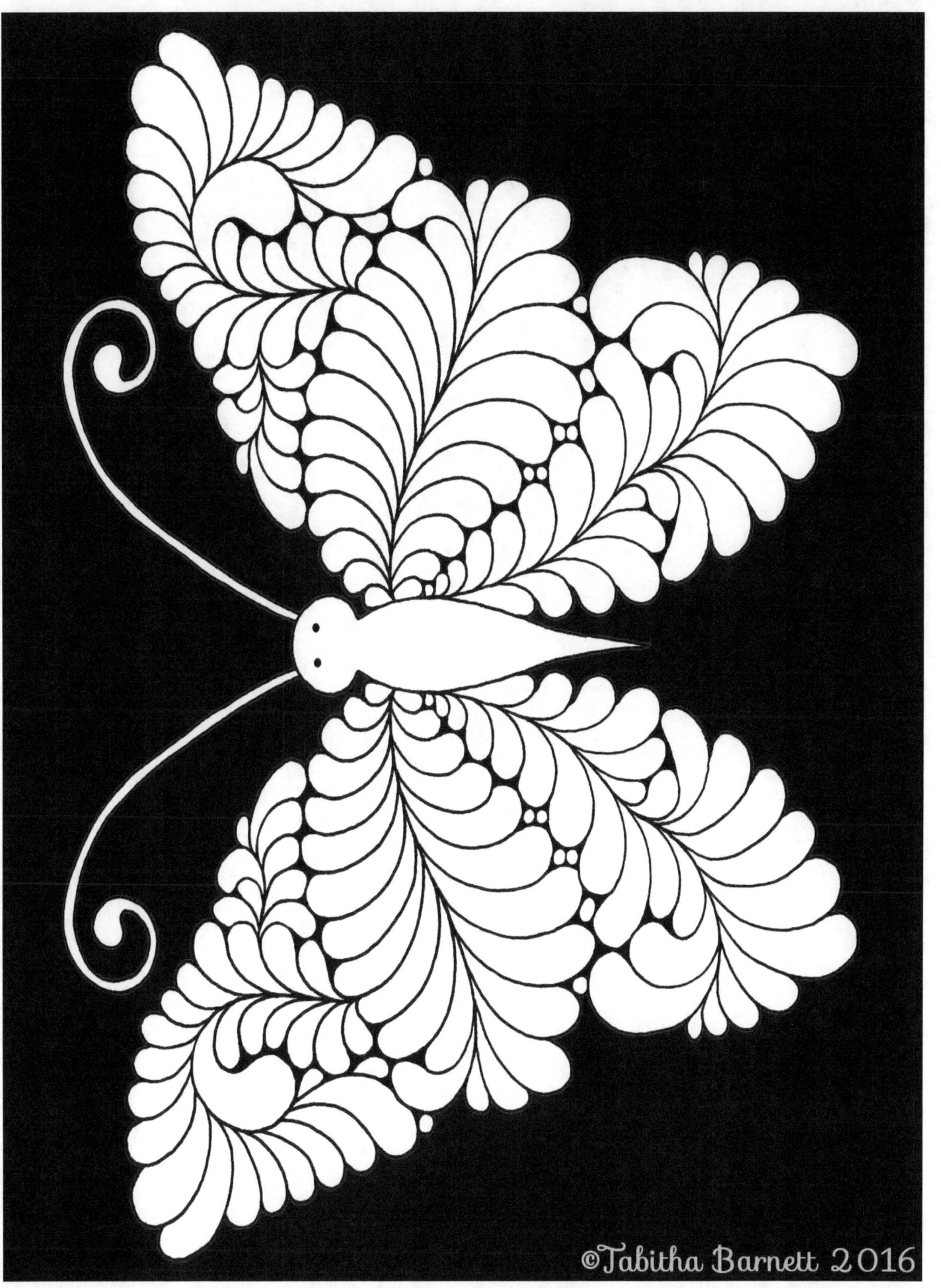

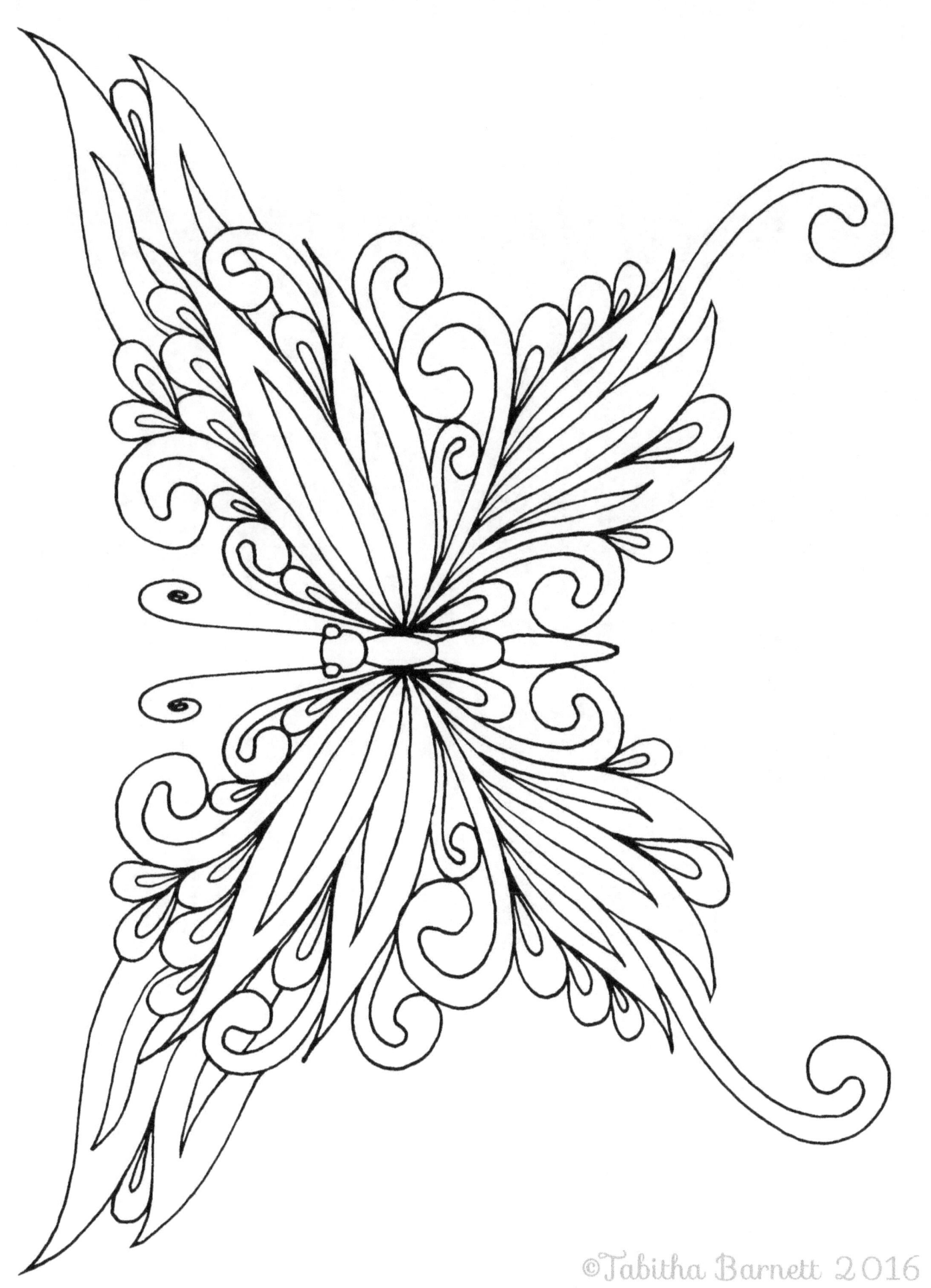

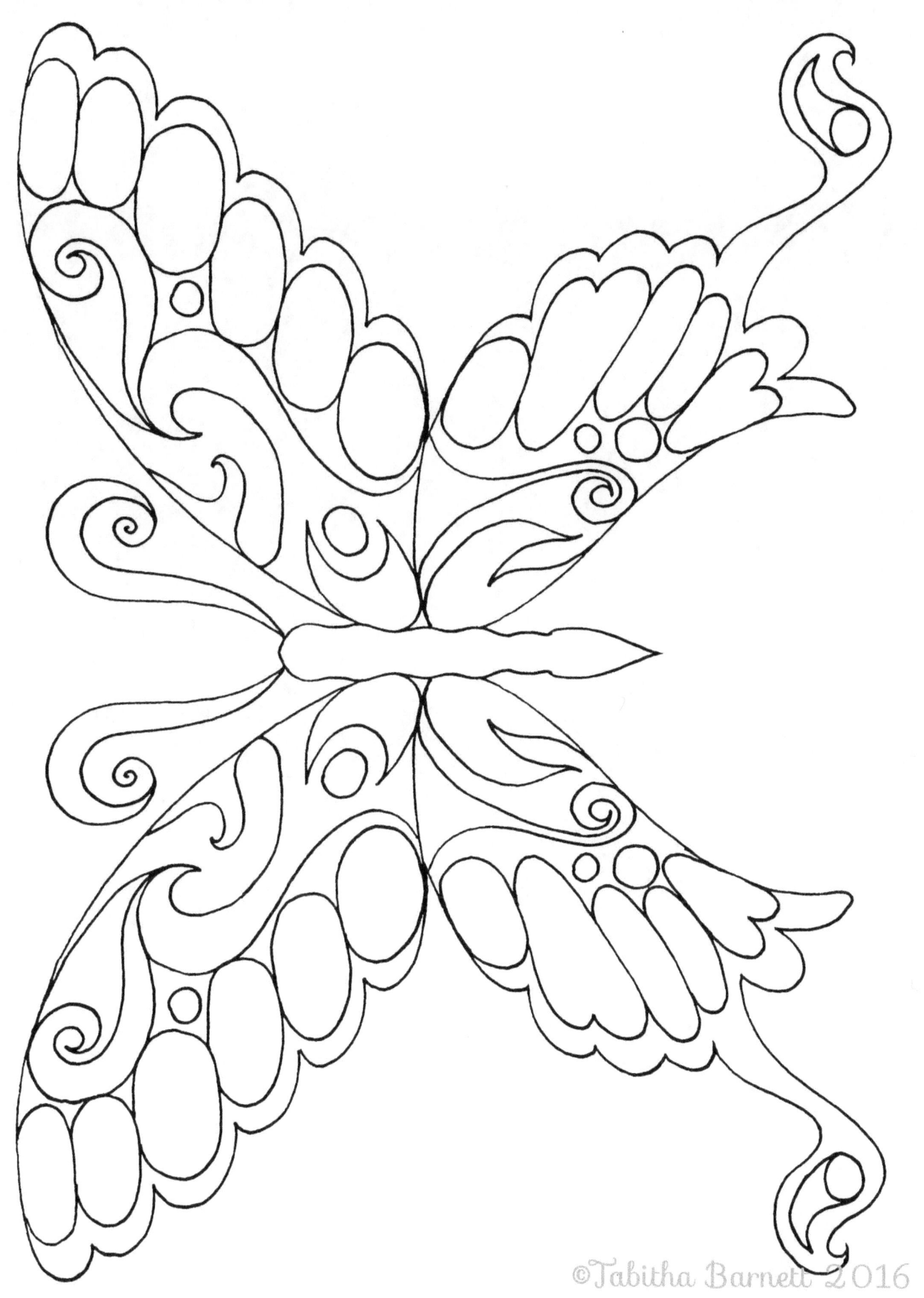

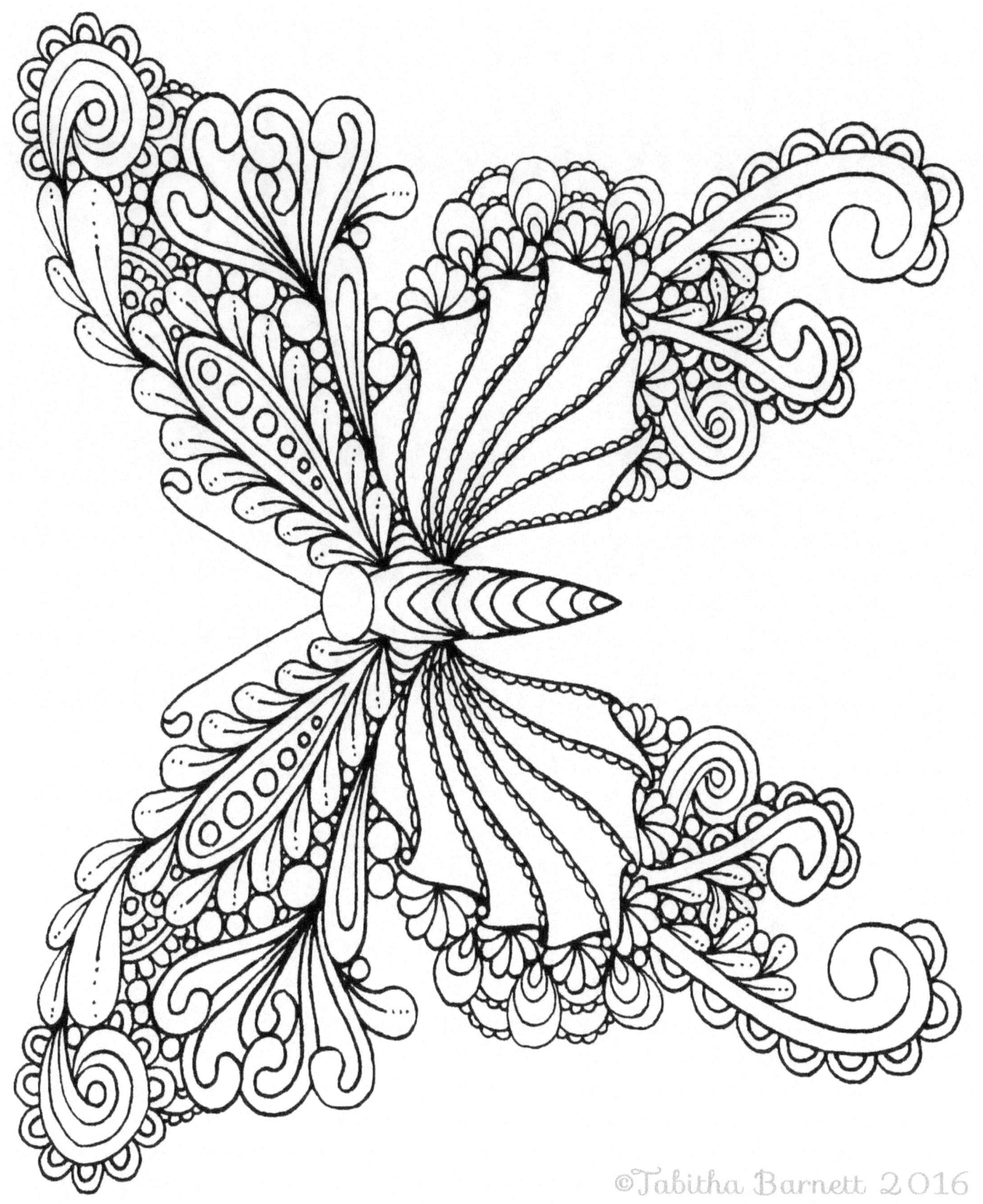

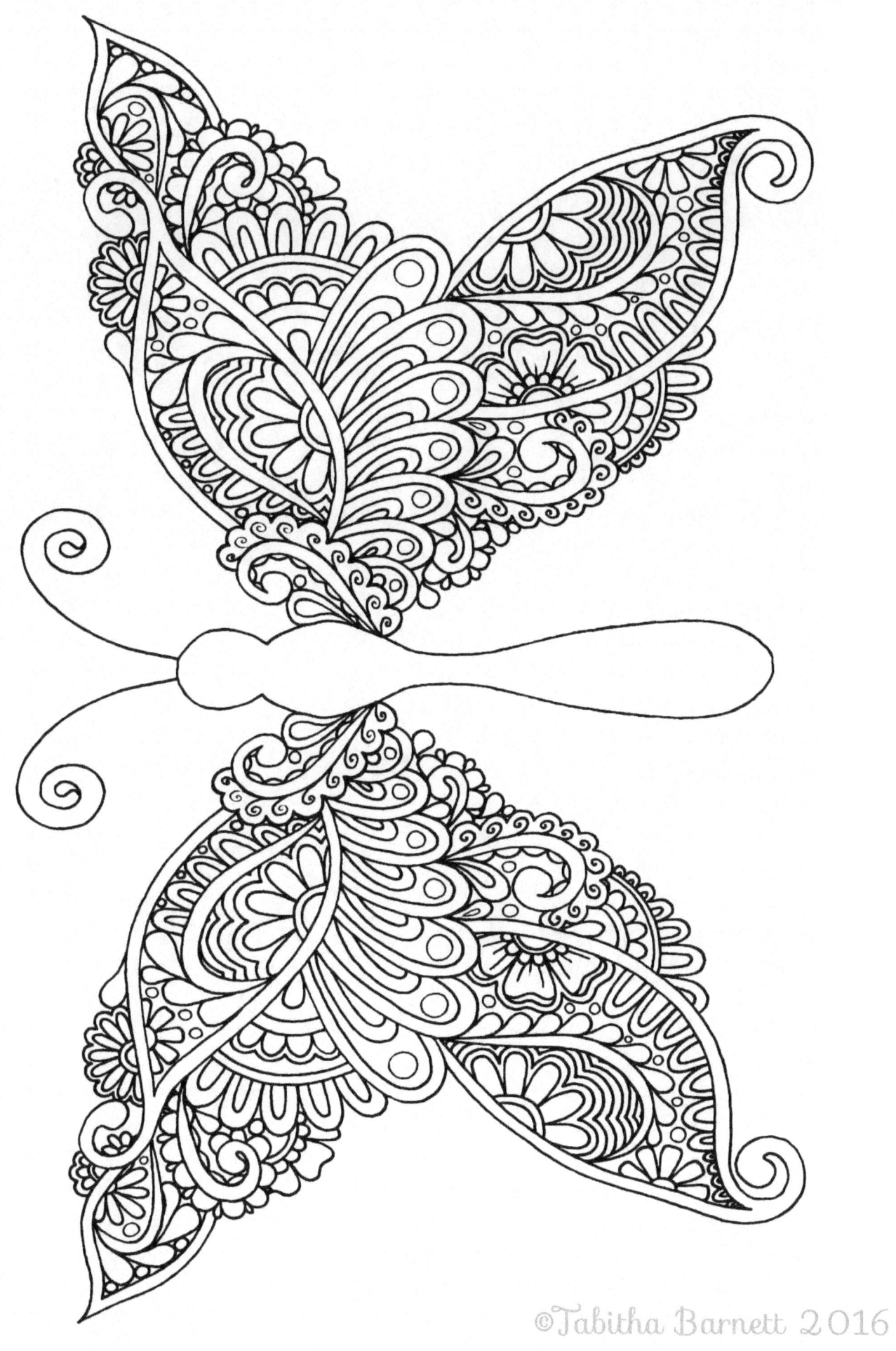

Thank you for your purchase. I hope you enjoy this book as much as I have enjoyed drawing and coloring these gorgeous butterflies! You can find lots of free coloring pages on my artist page: www.facebook.com/tabbystangledart. Please feel free to friend me (Tabitha L Barnett) on facebook as well. You can also find me on twitter: @tabbyleann and Google Plus: tabbystangledart@gmail.com.

Find more here:

www.patreon.com/tabbyb
www.redbubble.com/people/tabbyb
www.sellfy.com/tabbyb
www.amazon.com/author/tabbystangledart

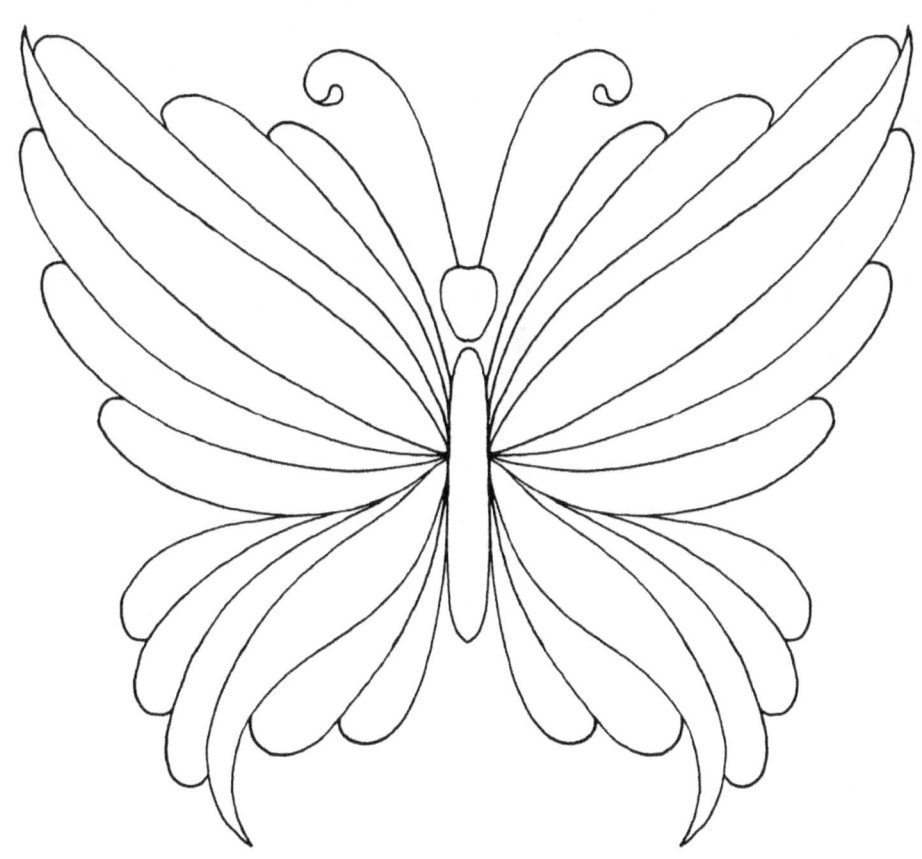

©Tabitha Barnett 2016

Color Chart

Medium: _____ **Brand:** _____